Praise for *The Listening Path*

"Julia Cameron has done it again. In *The Listening Path*, she gently guides us to become more in tune with ourselves, our world, each other, and beyond—bringing more clarity, connection, and joy into our lives. Whether you're a seasoned creator or just getting started, *The Listening Path* will guide you to access the treasure trove of wisdom that lives within, and in the world around you."

—Amber Rae, author of
Choose Wonder Over Worry

"Julia Cameron brought a new approach to creativity to the world with her extraordinary book, *The Artist's Way*. Now, in *The Listening Path*, she takes us into a completely different dimension of creativity: the ability to listen at deeper and deeper levels. As a lifelong student of the art of listening, I can tell you there is nothing quite like this book. I encourage you to read *The Listening Path* and make use of its life-changing gifts."

—Gay Hendricks, Ph.D.,
New York Times bestselling author of
The Big Leap and *Conscious Luck*

Praise for Julia Cameron and *The Artist's Way*

"Julia Cameron invented the way people renovate the creative soul."

—*The New York Times*

"Without *The Artist's Way*, there would have been no *Eat Pray Love*."

—Elizabeth Gilbert

"If you have always wanted to pursue a creative dream, have always wanted to play and create with words or paints, this book will gently get you started and help you learn all kinds of paying-attention techniques; and that, after all, is what being an artist is all about. It's about learning to pay attention."

—Anne Lamott

"This is a book that addresses a delicate and complex subject. For those who will use it, it is a valuable tool to get in touch with their own creativity."

—Martin Scorsese

THE
LISTENING
PATH

THE
LISTENING
PATH

The Creative Art
of Attention

———∞∞∞———

JULIA CAMERON

ST. MARTIN'S
ESSENTIALS

NEW YORK

Published in the United States by St. Martin's Essentials, an imprint of
St. Martin's Publishing Group

www.stmartins.com

Library of Congress Cataloging-in-Publication Data

Names: Cameron, Julia, author.
Title: The listening path : the creative art of attention / Julia Cameron.
Description: First edition. | New York : St. Martin's Essentials, 2021. |
 Includes index.
Identifiers: LCCN 2020035330 | ISBN 9781250768582 (trade paperback) |
 ISBN 9781250799746 (hardcover) | ISBN 9781250768599 (ebook)
Subjects: LCSH: Creative ability. | Listening. | Attention. | Mindfulness
 (Psychology)
Classification: LCC BF408 .C175555 2021 | DDC 153.6/8—dc23
LC record available at https://lccn.loc.gov/2020035330

Our books may be purchased in bulk for promotional, educational, or business
use. Please contact your local bookseller or the Macmillan Corporate and
Premium Sales Department at 1-800-221-7945, extension 5442, or by email at
MacmillanSpecialMarkets@macmillan.com.

First Edition: 2021

10 9 8 7 6 5 4 3 2

To Joel Fotinos,
for listening to my dreams

CONTENTS

Introduction 1

WEEK 1:
Listening to Our Environment 37

WEEK 2:
Listening to Others 59

WEEK 3:
Listening to Our Higher Self 111

WEEK 4:
Listening Beyond the Veil 143

WEEK 5:
Listening to Our Heroes 155

WEEK 6:
Listening to Silence 167

Afterword 179

Acknowledgments 181
Index 183

THE
LISTENING
PATH

INTRODUCTION

It is almost seven P.M. on a July evening in Santa Fe, and the sky is still a bright, azure blue. I sit on a bench amid trees and flowers. Birds chirp in the tree nearby. I can't see them, hidden in the tapestry of leaves, but I hear them as clearly as if they are next to me on the bench. Farther in the distance, a raven caws. Is it communicating with my nearby songbirds, or is its conversation unrelated? Farther off, a dog barks. A light breeze shifts the tall purple flowers by my bench and they rustle against one another as they sway back and forth. A car passes by, its engine quieter than its heavy wheels crunching through the gravel below. Far in the distance, a horn honks on the main throughway. Wings flutter as a bird lights to the sky, gliding away and out of sight. Nearby, the songbirds' chatter has slowed, but they still sing, a tuneful discussion in the greenery above. Earlier, it sounded as if they were all speaking at once. Now they seem to be taking turns. Are they listening to each other?

And what does it mean, to listen? What does it mean for us in our everyday lives? We listen to our environment, whether it is the chirping of birds or the commotion of

the city streets—or perhaps we don't listen, tuning it out instead. We listen to others—or perhaps we wish we listened better. Others listen to us—or we wish they did. We listen for our instincts, our hunches, our guidance—and perhaps we wish we could hear them more clearly and more often. The listening path asks us to tune into the many cues and clues that surround us every day. It asks us to take a moment to stop and listen—and argues that the moment spent tuning in, especially when we think we "don't have time," doesn't take time, but gives us time . . . and gives us clarity, connection, and direction as well. Listening is something we all do—and something we can all do more of. Every life can be improved by improving our listening. The listening path is a gentle path, with tools along the way to become better listeners—to our environment, our fellows, and ourselves.

This book will serve as a guide, urging the reader to listen more carefully and to listen in deeper and deeper ways. When we listen, we pay attention. And the reward for attention is always healing. The listening path brings us healing, insight, and clarity. It brings us joy and perspective. Above all, it bring us connection.

THE PATH TO DEEPER LISTENING

Over the next six weeks, you will be guided to expand your own listening, one level at a time. Each form of listening builds upon the next. I have learned that if we consciously work to listen, our listening deepens quickly. Deepening our listening is not time consuming so much as it is a matter of paying attention. This book will guide you to deeper and deeper listening within the life you've got, whether your schedule is busy or open, whether you live in the country or in the city.

We all listen, and we all listen in a myriad of ways.

We listen to our environment, where tuning in to the

sounds we might habitually tune out brings us surprising delight: the birds in the tree above enchant us; the tick-tick-tick of the kitchen clock brings us steadiness and comfort; the jangle of the dog's tags on the water bowl reminds us of the determination of life.

We listen to other people, and we learn that we can listen more closely. When we listen—really listen—to what others have to say, their insight often surprises us. When we don't interrupt, but wait, allowing our companions to extend a thought instead of rush to complete it, we learn that we can't in fact anticipate what they will share. Instead, we are reminded that we each have so much to offer, and that, given the chance, our companions will offer something more than, and different from what we might expect. We just have to listen.

We listen to our higher self, and in doing this, we are led both to guidance and to clarity. We do not struggle to think something up; rather we listen and take something down. Very little effort is required; what we are after is accuracy of listening. The voice of our higher self is calm, clear, and plainspoken. We accept each insight as it comes to us, trusting the often-simple thoughts that appear as ideas, hunches, or intuition.

Practiced in listening to our higher selves, we are ready to listen yet more deeply, reaching beyond the veil to listen to those close to us who have passed on. We find the unique and individual ways that our connection remains intact, and the ability to explore and expand that connection with ease. Reaching further still, we learn to listen to our heroes, those who we have not met but wish we had. And finally, we learn to listen to silence, where we may find we discover the very highest form of guidance. One step at a time, the listening path is a gracious experience of becoming more in touch with our world, ourselves, our beloveds, and beyond.

Let us listen.

THE BASIC TOOLS

I have taught live workshops in creative unblocking for forty years. I have watched students become unblocked, blossoming creatively, whether that means publishing books, writing plays, opening galleries, or redecorating their homes. I have also seen a distinct and consistent change in my students as they work with the tools: they become happier and more user-friendly. Many relationships heal and improve. Relationships that need to end are allowed to do so. Collaborations are openhearted and productive. As my students become more honest with themselves, they become more honest with others. As they are gentler with themselves, they are gentler with others. As they are more daring, they inspire others to dare.

I have come to believe that these changes happen because, through the use of the tools, students become better listeners—first to themselves, and then to others. The listening path takes this observation and dives deeper into the root of all creation and connection: our ability to listen.

And so, the basic tools remain the same: Morning Pages, Artist Dates, and Walks. Each tool is inherently based in listening—and each develops our listening skills in specific ways. With Morning Pages, we serve as a witness to our own experience, listening to ourselves each morning and thus clearing the way for further listening throughout the day. With Artist Dates, we listen to the youthful part of ourselves who craves adventure and is full of interesting ideas. And with Walks, we listen both to our environment and to what might be called our higher power or higher self—I myself, and my many students, have found that solo walks consistently bring what I like to call ahas.

I have written forty books. When people ask me how

I do it, I tell them I listen. They sometimes think I'm being glib. But I'm not being glib; I'm describing my writing process in the most accurate way I know how. Writing is a form of active listening. Listening tells me what to write. At its best, writing is like taking dictation. There is an inner voice—that voice speaks to us when we listen. It is clear, calm, and guided. It is surefooted, putting one word after another, unspooling the thread that is our train of thought.

Focused on conscious listening, we become aware of a listening path: a path grounded in what we hear. When we listen, we are led spiritually. Listening for our emerging truth, we become increasingly true to ourselves. Honesty becomes our currency. We are given a glimpse of our souls.

"To thine own self be true," the bard advised us. And when we are true to ourselves, we deal more truthfully with others. The listening path leads us to connection. The listening path is communal. We meet and greet our environment, our fellows, and ourselves.

Because it is sourced in honesty, the listening path is a spiritual path. As we listen for our personal truth, we hear a universal truth. We tap into an inner resource, which can be called grace. As we work to listen more and more authentically, we find ourselves ever more honest. A step at a time, we are training ourselves to honesty. In time, it begins to be automatic.

The habit of listening must be formed and practiced, and there is a simple way to begin it. You may start as I started—and still start each day: with the practice of Morning Pages. And what are they?

MORNING PAGES

Morning Pages are a daily practice of three pages, stream of consciousness, written first thing upon awakening. I,

and many others, have used them for decades and have found them to be the most powerful tool to practice listening. The pages are about anything and everything. There is no wrong way to do them. They range from the petty to the profound.

"I forgot to buy kitty litter. . . ." "I didn't call my sister back. . . ." "The car has a funny knock in it. . . ." "I hated that Jeff took credit for my idea. . . ." "I'm tired and I'm grumpy. . . ."

Morning Pages are like a little whisk broom that you poke into all the corners of your consciousness. They say, "This is what I like. . . . This is what I don't like. . . . This is what I want more of. . . . This is what I want less of. . . ." The pages are intimate. They tell us how we really feel. In the pages there is no room for evasion. We tell ourselves we feel "okay," and then we tell ourselves what we mean by that. Does "okay" mean "not so good" or does it mean "fine"?

Pages are for your eyes only. They are private and personal, not to be shown to anyone, however close they are to us. Pages are written out longhand, not by computer. Writing by hand yields us a handmade life. Writing by computer is faster, but speed is not what we are after. We are after depth and specificity. We want to record exactly how we feel and why.

Pages puncture denial. We learn what we really think, and it is often a surprise to us.

"I need to leave this job," we may find ourselves saying. Or "I need more romance in my romance." Pages nudge us toward action. Something that seemed "good enough" no longer seems that way. We admit we may deserve better, and then we admit our own inertia: our regrettable tendency to settle, which we have now outgrown.

Pages are a form of meditation. We write down our "cloud thoughts" as they cruise through our consciousness.

But pages are meditation with a difference: unlike conventional meditation, they move us to action. They do not "meditate away" our concerns. Instead, we write them out, and as we do, we are faced squarely with the question: "What are you going to do about that?"

Pages corner us into action. They do not settle for anything less. They tutor us into taking risks—risks on our own behalf. The first time pages raise the notion of action, we may find ourselves thinking, "I couldn't do that!" But pages are persistent, and the second time they raise the notion, we may find ourselves thinking, "Maybe I could try that." As the pages edge us further on, we find ourselves recording, "I believe that I'll try . . ." And we do try—and quite often we succeed.

"I knew you could do it," the pages may crow. Pages are a companion. They witness our lives. We find ourselves "taking to the page" in times of confusion. Pages help us to sort our often conflicting ideas. We write, "I think I need to break off my relationship." And then we write, "Maybe I need instead to try a risky conversation." We try the conversation and find ourselves delighted with the result.

Morning Pages are wise. They put us in touch with our own wisdom. We find ourselves tapping an inner resource that gives us answers to our many and varied problems. Our intuition is heightened. We find unexpected solutions to situations that used to baffle us. The spiritually inclined among us begin to speak of God. God, they say, is doing for us what we could not do for ourselves. Whether we call our helper God or simply the pages, we experience breakthroughs. Our lives begin to run more smoothly. We come to count on it.

"Do you still do Morning Pages?" I asked a colleague who taught with me twenty years ago.

"I do them whenever I get in trouble," he replied.

"But if you did them regularly, you wouldn't get in trouble," I chided him—realizing that I sounded like a bleeding deacon.

Yet it has been my experience—forty years' worth—that Morning Pages ward off difficulties. They give us a heads-up when trouble is looming. Pages are fearless: they do not hesitate to broach unpleasant topics. Your lover is growing distant, and pages mention this unsettling fact. Nudged by the pages, you instigate a difficult conversation. The risk pays off. Intimacy is restored.

Pages mentor us. They help us to grow in needed directions. They perform what I call "spiritual chiropractic," adjusting us in needed directions. Loudmouths learn to keep their counsel. Milquetoasts begin to speak up. Always, we are moved in the direction needed. Pages are uncanny in their insights and adjustments.

Make no mistake: pages are a tough-love friend. If there is an issue we have been avoiding, pages will point this out. I received a letter: "Julia, I was perfectly happy drunk in the Outback. Then I started Morning Pages. Now I'm sober. . . ."

Drunkenness, overweight, codependency—pages will tackle them all. We are nudged in the right direction, and if a nudge doesn't work, we are shoved. Pages put an end to procrastination. We act in the direction indicated, if only to get the pages to shut up.

A woman in Canada writes, "I've never been one to journal or keep a diary, but pages intrigued me." Intrigued, she began the practice. Within weeks she began to reap the benefits. Unlike conventional journaling, where we typically set a topic—"I'm going to write everything I feel about Fred or my mother"—pages are freeform. They feel—and are—scattered. We skip from topic to topic to topic—a sentence here, a sentence there. My

Canadian correspondent found herself poking into odd corners and gathering insights in many directions.

Pages can be profound or petty. Frequently they are both. A "little something" bothers us, and is revealed upon further writing to be the tip of an iceberg. How we feel about the issue matters. We write "I feel," and then we write "I really feel." Layer by layer we become intimate with ourselves. We discover our hidden self, and the realizations are thrilling.

Because self-knowledge is exciting, pages are addictive. The listening path that they inaugurate is never dull. People who start out declaring "My life is dull" soon find those same lives riveting. The examined life becomes a rich resource. "I didn't know I felt that way" is the sentence that accompanies some new nugget of self-knowledge.

"Julia, I learned more in a few weeks of Morning Pages than I did in my years of therapy," reports one practitioner. This is because pages gave him a glimpse of what might be called "the undefended self." Jungians tell us that upon awakening we have about a forty-five-minute window before our ego's defenses are in place. Catching ourselves off guard, we tell ourselves truth, and truth may differ markedly from our ego's version of events. As we listen—and record—our actual feelings, we become habituated to the truth. We puncture "I feel okay about that" to reveal that we may not feel okay at all. As we discover our authentic feelings, we discover our authentic selves, and those selves are fascinating.

"Julia, I fell in love with myself!" is a sentiment often exclaimed with wonder. Yes, pages teach us to love ourselves. Because we accept each thought that comes to us, we learn radical self-acceptance. Listening for thought after thought, we come to anticipate with eagerness just what we are up to. Each new thought unfolds another layer of our self. Each layer tutors us further in our lovability.

Because we reject no thoughts, we teach ourselves that all parts are welcome here. This welcoming attitude is the bedrock of the listening path. A word at a time, a thought at a time, we accept our insights and ideas. No thought is turned away as unworthy. "I feel grumpy" holds equal sway with "I feel wonderful." Dark thoughts and light thoughts are equally valid. We are hospitable to all moods.

The listening path takes practice. We "hear" thoughts and our next thoughts, but the "still small voice" that we hear is subtle. It is tempting at first to discount what we hear as "just our imagination." But the voice is real, just as our connection to the divine is real. If we ask for reassurance, we hear, "Do not doubt our bond." And so we continue to listen, and as we do, we come to trust our guidance. Morning Pages become a reliable resource. What at first seemed farfetched, over time becomes dependable.

WRITING MORNING PAGES is like driving with the high beams on: we "see" ahead of ourselves, farther and more clearly than our normal low-beam vision. Potential obstacles stand out clearly. We learn to avoid trouble. Equally valuable is our pages' ability to spot opportunity. Our "luck" improves as we pick up the cues our pages are sending.

"I never believed in ESP," a recent letter protested. "But now I think there's something real going on. Pages are uncanny." The "uncanny" knack of Morning Pages shows itself most often as synchronicity. We write about something in our pages, and the something that we write about shows up in our life. Our wishes become tangible. "Ask, believe, receive" becomes a working tool of our consciousness. As we work with pages, we find ourselves being ever more candid. We write out our true wishes, and the universe responds.

"I didn't believe in synchronicity," one skeptic wrote. "Now I count on it."

So do I.

I wrote in my pages that I yearned to make a film. Two days later, at a dinner party, I found myself seated next to a filmmaker. Furthermore, he taught filmmaking. I told him my dream, and he said "I've got one slot left. If you want it, it's yours." I did want it. My next pages recorded my gratitude.

Although pages can be about anything and everything, gratitude is fertile ground. Counting our blessings on the page makes room for more gratitude. When we say "I have nothing to write about," we can turn our lens toward the positive, enumerating our blessings from large to small. A sober alcoholic can say "Thank you for sobriety." A fit person may give thanks for health. All lives contain grounds for gratitude. The listening path numbers myriad causes for a grateful heart. Focusing on the positive breeds optimism. Optimism is a primary fruit of the listening path.

The deliberate shift from negative to positive can be done whenever we find ourselves with "nothing to say." All lives contain something to be grateful for, even if that something is rudimentary. "I'm grateful I'm alive. I'm grateful to be breathing. . . ." Fundamentally, each life is a miracle, and by acknowledging this fact, we celebrate life itself.

"Be still, and know that I am God," the Scriptures advise us. As we practice listening, we come to sense a benevolent *something* that touches our consciousness with a feeling of belonging. With pages as our witness, we are no longer alone. Rather, we are partnered by an interactive universe. I recently tried to put this fact into words. "The answer to my prayer? A listening God who knows I'm there." It is not hubris to conjure a "listening God." The practice of pages is a spiritual practice. As we write, we

"right" our world view. The world changes from a hostile one to a benevolent one. As we listen, we are led—led carefully and well.

THE PRACTICE OF writing Morning Pages quickly develops into a habit. Scientists tell us it takes ninety days to groove a new habit. But Morning Pages become a habit in far less time than that. As a teacher, I have observed two to three weeks as the turning point. It is a short investment of time for a large payoff. The habit of pages yields us a spiritual path. That path—the listening path—both guides and guards us.

My colleague Mark Bryan compares the practice of pages to a NASA launch: we fire off daily pages and the change seems slight—a few degrees from our normal life. Over time, those few degrees are the difference between landing on Venus or Mars. The slight shift in our trajectory looms large.

I recently did a book signing, and at reading's end, a man approached my desk. "I want to thank you," he said, "for a quarter century of Morning Pages. In all that time, I missed only one day—the day I got quadruple bypass surgery."

I sometimes miss pages on early travel days. Arriving at my destination, I do "evening pages," but they are not the same. Writing at night, I am reflecting on a day I already had and am powerless to change. Morning Pages lay out my day's trajectory. "Evening pages" record the day's journey as hit or miss. Belatedly, I see the day's many "choice points"—places where I could have chosen more productively. Instead, I squandered my day.

Morning Pages are frugal. They make the best, most productive use of the day at hand. "Pages give me time," a woman told me recently. "They appear to take time, but they give me time instead." I am familiar with this

paradox. I write for forty-five minutes in the morning, but then throughout the day I seize many "spare moments." I spend my time according to my own priorities. Time becomes *my* time.

Writing pages, we move through our days more efficiently. We eliminate what I call "mental cigarette breaks"—those long pauses while we ponder what to do next. With pages in place, we move smoothly, activity to activity. "I could do X," we think, no longer procrastinating. We do "do X"—grabbing time and using it in our own best interest.

I have sometimes said that pages are a radical codependency withdrawal. We spend our time on our own agendas—no longer on the agendas of others. We are often stunned to discover the amount of time and attention we have spent "people-pleasing" others. As we withdraw our energies back into our own core, we are shocked by the power that is suddenly ours to do with as we please. Many of us have spent our lives being batteries for others. We have worked to fulfill their dreams, neglecting our own. Suddenly, with pages in place, our dreams are within our reach. As we take each small step that the pages indicate, our dreams become our reality.

"Julia, for years I wanted to write and didn't. Then I did pages. Here is my novel. I hope you enjoy it." With that, I was handed a book.

I've often remarked that teaching, for me, is like visiting a garden. I'm handed books, videos, CDs, jewelry. People have used my tools and the seeds of creativity have sprouted.

"I directed a feature film," an actor told me exultantly. "I owe it to the pages." I was thrilled for him, recognizing a dream come true.

———

WITH MORNING PAGES, we dare to listen to—and articulate—our dreams. We say what before might have been unsayable. The successful actor dreams of being a director. An advertising copywriter yearns to write a novel. What before may have seemed grandiose, with pages becomes suddenly feasible. We are encouraged to dare, and having dared, we are encouraged to dare further. We are becoming "rightsized," and that right size is larger, not smaller. Where once we were afraid of being "too big for our britches," we now expand, not contract. In the words of Nelson Mandela, we see that what we have feared was our true size—larger, not smaller.

We begin to see that "the sky is the limit," and that sky is big, bright, and expansive—not overcast and gloomy. "I wish I could" becomes "I think I can." We are like the little engine who could from the children's book about daring to be large. As we change sizes, we may meet with opposition from our intimates, who are comfortable with our smaller size. In time, they will adjust. The good news is that pages are contagious. Seeing the changes wrought in us by pages, those near and dear to us may undertake pages themselves.

An accomplished acting teacher tells his class that the key to successful acting is listening. Pages train us to listen. "What you are after," the teacher continued, "is to be a conduit." He draws an arc in the air, tracing the listening path. "The energy moves through us," he explains.

As practitioners of Morning Pages, we practice the creative art of attention. We are alert to the cues of the next right thought. We "hear" the words that want to pass through us. We experience being a conduit, a hollow reed for energy to pass through.

Dylan Thomas wrote of "the force that through the green fuse drives the flower." He was talking about creative energy, the same energy we experience as we write our Morning Pages. With our inner ear cocked to "receive,"

we pick up subtle signals. Taking them down, we record a psychic path. We are led word by word to transcribe what we need to know and do. We learn to move past our censor, saying, "Thank you for sharing," and continuing to take down what we hear.

This trick of evading the censor is a portable skill. Practicing any art form, we encounter our censor and step past. "Thank you for sharing," we mentally note, and as we do so, we dismantle our perfectionist. Pages train us to trust our creative impulses. We become accustomed to "laying track," putting down word after word after word. We learn to trust that each word is perfect— good enough and even better than that. Our perfectionist protests in vain. We hear it as a wee peeping cry where once we heard it as the booming voice of truth. Our perfectionist becomes a nuisance, not a tyrant. With each successful page, we miniaturize its voice. Although we do not eliminate perfectionism entirely, we dramatically reduce its power.

WHEN I TEACH, I do a perfectionism exercise. "Number from one to ten," I tell my students. "Now I will give you a cue, and you will fill in the blank. Ready? Here we go. Number one: If I didn't have to do it perfectly, I'd try . . . Two: If I didn't have to do it perfectly, I'd try . . . Three: You'll detect a trend. If I didn't have to do it perfectly, I'd try . . . Four: If I didn't have to do it perfectly, I'd try . . . Continue up through ten."

Having named ten impulses that their perfectionism has thwarted, students find themselves thinking, "Actually, I could try . . ." For the first time they see their perfectionism as the boogeyman that it is. By listening to and listing their dreams, they move a notch closer to trying them.

The pages dare us to expand. We listen to our heart's

desires and we listen to the voice that says, "Maybe I could try that." We dismantle our negative conditioning, the villainous hiss that tells us, "No, never, I couldn't." The truth is that we could, which converts to "I can."

We can do a great deal more than our fears would have us believe. Perfectionism is fear in a fancy dress. We are afraid of looking foolish, and so we hang back, telling ourselves we are being sensible. The truth is, there is nothing sensible about hanging back. We deprive ourselves of the joy of creation. We deny our human need to create. Our dreams and desires are intended to be fulfilled. Hanging back, we thwart our true nature. We are intended to be creative, to attend to the whisper that says, "You can, just try."

THE LISTENING PATH requires attention. Our dreams are often soft-spoken. As we listen to their whispered voice, our hearing becomes more acute. Our daily pages tutor us in the art of attention. As we listen to each thought as it unspools, we come to trust our own perceptions. Each word marks a point of consciousness. Taken collectively, the words are the jottings of our souls. As we attend to their unfurling, we pay attention to the narrative of our lives. Far from colorless, our stories are multicolored, rich in their patterns. As we heed our dreams, more dreams unfold for us. Examining our lives, we find our lives to be worth examining.

Morning Pages open a door. Whereas before, our lives were terra incognita, they are now known to us. Our feelings go from mysterious to clear. We know what we feel and why we feel that way. There is a place for us in the larger scheme of affairs.

The listening path tells us what we need to know. Events do not sneak up on us. With our heightened intuition, we often sense the shape of things that are to come.

Friends will remark on our seemingly uncanny ability to land on our feet. To us, it is no mystery. Rather, it is the fruit of our Morning Pages. We have come to rely upon pages as sort of an early warning system. We pick up subtle cues of dis-ease. Over time, these cues verge upon ESP. We come to rely on them. We pay attention to our "funny feelings." We take them seriously.

As we travel the listening path, we develop faith that we are safe. Too many times we are warned of trouble pending. We come to trust that there is a benevolent *something* that intends us good. This something speaks to us through pages. Our inklings prove to be reliable guidance. Our hunches are inspired.

"Do this. Try that," our pages suggest, and as we act on their suggestions, we discover that their guidance pays off. Urged in novel directions, we find the new territories to be rewarding. Pages urged me to try writing music. "You will be writing radiant songs," I was told.

"But I'm not musical," I protested—until I tried to write music and found myself indeed writing radiant songs. Now, when I teach, I have my classes sing some of these songs. They are loved, and I love hearing them sung. It catches the class by surprise when I tell them I wrote the songs. It is a talent they didn't know I had, and one that only the pages revealed.

We enter our pages thinking we know our talents. We are, we believe, just so talented and nothing more. We are, if you would, a certain height. But then the pages have their way with us, and we discover that we are creatively taller than we had supposed. I thought music was beyond my reach only to discover I was musically gifted. Similarly, a non-writer may discover a knack for writing, or a non-artist may uncover an artistic flair. Our gifts are many, and often unsuspected.

"But, Julia, how could we not know?" I am sometimes asked. In answer, I cite my own case. I was raised

as the "non-musical" one in a very musical family. In my family lore, I was a writer, not a musician. When pages suggested I try writing music, I thought they were nuts—until I tried it.

The family mythology is powerful—so powerful that when I told my musician brother that I was working with a composer and had played him some pieces, he said, "This guy is talented." But when I admitted that the composer was me, my brother said, "The last number was okay."

I tell this story to demonstrate the strength of familial conditioning. My beloved brother simply could not believe that I was musically talented. I had trouble believing it myself. Now, with three musicals and two collections of children's songs to my credit, I still stumble over the phrase "I'm a musician," although the pages are certain of my talent.

IT IS MY conviction that pages function as what I call "believing mirrors." They reflect back to us belief in our potential. They are optimistic and positive. They believe in our strength, not our weakness. Every artist needs believing mirrors—not only the pages, but people as well. When I teach, I ask my students to list three believing mirrors—those people who offer encouragement and support. The pages offer both. Believing mirrors are pivotal to creative success. Success, after all, occurs in clusters and is born in generosity. As we name our believing mirrors, we become able to use them more consciously. I have believing mirrors in my friends. Gerard, Laura, Emma, and Sonia. I run my early drafts past them because they are "safe." Their support and encouragement enable me to undertake further drafts. They are, like Morning Pages, a cheering section.

When I finished my novel *Mozart's Ghost,* I submitted

it for publication with high hopes. My hopes were soon dashed as editor after editor reported to my agent, "I loved Julia's novel, but I couldn't get it past committee." No matter that these rejections were near misses; they were rejections nonetheless. As their numbers grew, my faith waned, but I had a believing mirror in my friend Sonia Choquette.

"Your novel is good," Sonia insisted. "I see it getting published." And so, bolstered by Sonia's belief, we continued submission after submission. With each disappointment, I said to myself, "Sonia thinks the novel is good. Sonia sees it being published." My Morning Pages also waxed optimistic. Encouraged, I pushed on. My agent, Susan Raihofer, was gallant and game. She kept on trying until—bravo!—submissions forty-three and forty-four both wanted the novel. We chose submission forty-three, St. Martin's Press. I am convinced that without the pages and Sonia, I would have given up. My believing mirrors helped me go the distance. I am tickled that I did.

"Your novel is so good," readers tell me. They echo Sonia's sentiment. I am grateful to Sonia and to my pages that I kept on. Believing mirrors give us stamina and optimism. They are pivotal to creative success.

"Keep on keeping on" is the mantra of Morning Pages. "Don't stop five minutes before the miracle." Make no mistake: the pages do create miracles.

"I do Morning Pages because they work," pronounces one twenty-year practitioner. "I do pages because then I happen to the day, instead of the day happening to me."

"You make wishes in your Morning Pages, and a lot of times they come true," volunteers another believer. "I began pages as a disillusioned classical violist," antes up Emma Lively. "Pages convinced me to try composing. Now I am a composer."

"Ditto," says another practitioner. "I was jealous of playwrights. Now I am one."

Morning Pages are simple but dramatic. They turn us into who we want to be. What could be better than that?

◄ TRY THIS ►

Set your alarm forty-five minutes early. Spill from the bed straight onto the page. Write three pages longhand about anything and everything that crosses your mind. At the end of three pages, quit. Welcome to Morning Pages. They are the gateway to the listening path.

THE ARTIST DATE

The Artist Date is the tool of attention. It has two differing emphases: "artist" and "date." Put simply, an Artist Date is a once-weekly solo expedition to do something that enchants or interests you. It is half artist and half date. You are "wooing" your artist. Planned ahead of time—hence "date"—this weekly adventure is something to look forward to. As with a romantic date, anticipation is half the fun.

When I teach, I find myself facing resistance—not for the work of Morning Pages, but for the play of the Artist Date. Our culture has a strong work ethic, but we have no "play ethic." And so, when I introduce Morning Pages—"I have a tool for you. It's a nightmare. You must get up forty-five minutes early and take to the page"—I can see heads nodding. My students "get" that this tool might be very valuable, and so they readily commit to doing it.

But when I introduce Artist Dates—"I want you to do something that intrigues or enchants you for an hour or two weekly. In other words, I want you to play"—arms cross defiantly. What good could "play" possibly do? We

understand working on our creativity. We don't realize that the phrase "the play of ideas" is actually a prescription: play, and you will get ideas.

It is astonishingly difficult to undertake assigned play. "Julia, I can't think of an Artist Date," I am sometimes told. Once again, this plea comes from a lack of play. Rather than be playful, these students are overly serious. They believe that they must find the "perfect" Artist Date.

Nonsense, I tell them. Then I ask them to number from one to five, and quickly, off the top of their head, list five possible Artist Dates. When a list of five simple pleasures seems impossible to come up with, I give my students a tip: Pretend you are a youngster. Name five things you as a youngster could enjoy. Grudgingly, the playlists are generated.

1. Go to a children's bookstore.
2. Go to a pet shop.
3. Go to an art supply store.
4. Go to a movie.
5. Go to the zoo.

After they have listed their initial five, I urge them to come up with five more. This takes a bit of digging, but soon five more are uncovered.

6. Visit a plant store.
7. Visit a botanical garden.
8. Visit a fabric store.
9. Visit a button shop.
10. Attend a play.

The minute Artist Dates are firmly established as *fun,* ideas for them abound. But for those who are still stymied, brainstorming with a friend turns the trick. Our

friend may say, "Visit a museum. Visit a gallery." Or, as one of my friends suggested, "Visit a hardware store."

The lists are for giddy delights—nothing serious here. This is not the time to undertake edifying adult pleasures, such as the computer course you've been meaning to take. The course is not an Artist Date. It is far too demanding. What we are after here is sheer fun. Nothing too harsh. And remember, it must be undertaken solo. On an Artist Date, you are wooing yourself. The adventure is not to be shared. It is private and personal: a secret gift you share with yourself alone.

EXECUTED SOLO, THE Artist Date is a special time during which your artist is the focus of your attention. "On Friday, I'm taking my artist to a meal out in Little Italy."

The Artist Date pushes us into a state of heightened listening. During the date, we become acutely in touch with ourselves and with what we might call our "inner youngster." It is common to experience resistance to this tool, but the rewards of listening so closely to ourselves are great. Alone with ourselves, doing something just for fun, we hear both our innermost desires—and often inspiration, or what feels like the hand of a higher force.

Making art, we draw from an inner well. We "hook" image after image. On our Artist Date, we are replenishing the well. We are consciously restoring our stock of images. The hour we spend spoiling ourselves pays off; when next we make art—fishing for images, remember—we find our well abundantly stocked. We hook images easily. There are plenty to choose from. We listen for the one that seems best.

On our Artist Date, we pay close attention to our experience. This attention rewards us with delight. Our sortie to Little Italy fuels our senses. Rich aromas and savory tastes grace our palate. Veal with lemon—veal

piccata—and freshly baked garlic bread tickle our taste buds. Back at home, writing on a different subject entirely, we find plentiful images as rich as our meal. A successful Artist Date pays off, but not in a linear fashion. We take Date A and we reap the rewards in Z Perhaps it is because the rewards are not linear, people find Artist Dates harder to practice than Morning Pages. Pages are work, and we have a highly developed work ethic. Artist Dates are play, and we do not take "the play of ideas" literally. We are willing to work on our creativity, but play? We don't see what good play can do.

But play can do plenty. As we lighten up, our ideas flow more freely. No longer straining to think something up, we relax, listen, and take something down. Hunches and intuitions come to us on Artist Dates. Many people report that during their Artist Date they felt the presence of a benevolent something that many identified as God.

"For me, Artist Dates are a spiritual experience," one practitioner reports. Think of it this way: With Morning Pages, you are "sending." With Artist Dates you have flipped the dial over to "receive." It is as though you are constructing a spiritual radio kit. You need both tools for it to work properly.

"I get my breakthrough ideas on Artist Dates," a woman tells me. I'm not surprised. Creativity experts teach that breakthroughs are the payoff of a two-part process: concentrate and then release. With Morning Pages, we are concentrating, focusing our attention on the problem at hand. With Artist Dates, we practice release, and our minds fill with new ideas. It takes the "letting go" for the process to work. This is why so many people report that their breakthroughs occurred in the shower or as they executed a tricky merge on the freeway. Albert Einstein was a shower person. Steven Spielberg is a driver. The critical point is focus, then release. Too many people strive for breakthroughs by focus without release. Artist

Dates are the remedy for this bad habit. The play of an Artist Date inaugurates the play of ideas.

The point of an Artist Date is enjoyment. A hearty dose of mischief characterizes the best dates. Do not be dutiful. Think mystery, not mastery. Think frivolity. Do not plan something you "should" do. Instead, plan something that perhaps you *shouldn't* do. Ride a horse-drawn carriage. Enjoy the clip-clop of iron-shod hooves. Artist Dates need not be expensive. Some of the very best are free. It costs nothing to browse the shelves of a children's bookstore. And the books found there are fascinating. *All About Reptiles. All About Big Cats. All About Trains.*

Artist Dates are childlike. The amount of information contained in a children's book is the perfect amount to set our artist humming. More information—the amount, say, in a book for grown-ups—can overwhelm our artist, leaving us feeling daunted. Remember, always, that our artist is youthful. Treat it as you would a child. Coax it rather than flog it forward. It will respond well to playfulness. Artist Dates—assigned play—are an ideal tool for increased productivity.

"I TOOK AN Artist Date at a pet store where I was allowed to pet the baby rabbits. Afterward, I wrote like a fiend," reports one happy student. Her favorite bunny was a female Lionhead—a fluffy specimen that was both gentle and playful. Back at home, out her living room window, she spotted several cottontails in quick succession. "It was as if I had my dial set to 'bunny,'" she laughs.

Pet stores, with their inherent playfulness, are an ideal Artist Date. But one practitioner swears by aquarium shops. "I could stay for hours," he tells me. "I am mesmerized by the tiny little neon tetras with their glow-in-the-dark stripes. And I have a love for fan-tailed goldfish,

with their fins floating like veils. The angelfish look so serene, but are actually aggressive. The swordtails are colorful, but very shy."

Paying attention to the natures of the differing fish is an act of attention. Attention is the primary characteristic of an Artist Date. We listen for the individual traits of each date, and we record them in our memory bank. When next we sit down to create a piece of art, we have a rich well to draw on. The particulars in our memory translates into specificity in art, and specificity is what engages the viewer.

Fine arts photographer Robert Stivers hangs each of his shows with care. The placement of each piece is important to him and to those who visit the gallery. Stivers's work ranges from the mysterious to the mystical. The beauty of his images is undeniable, from a wind-tossed sunflower to a solitary palm.

"I think of it like listening," Stivers says. "Something will catch my eye like a whisper catches my ear. It's a matter of attention." Driving across the desert, Stivers snaps photos from his car window. The images he captures are striking.

"I like some of what I get," he says modestly. His eye is ever alert, and his modesty has an understated dignity. Visiting a gallery on the eve of a show of his, I am treated to a sneak preview. Leafing through a hundred images, he takes particular pride in a series of animals in saturated color. A ram is hot pink, a buffalo is regal purple, a moose is green. The jolt of color makes each animal more memorable. Even Stivers has to admit he "likes some of what he gets."

A visit to a Stivers show is, for me, a perfect Artist Date. His images are so stunning, they jar the senses, inducing a childlike wonder. A single rose, caught at the point of decay, is a memento mori. A nude draped in cheesecloth is another.

A SUCCESSFUL ARTIST Date opens the door to creative exploration. What you see or hear opens the heart to what you feel. Emotion is unlocked. The whole person is engaged.

In planning an Artist Date, choose beauty over duty. You are out to feel enchantment. Jotting a quick list of ten things you love leads to a succession of Artist Dates. If you love horses, you could pet a horse. If you savor chocolate cake, you could visit a bakery. A cactus leads to a florist. All your loves lead somewhere, and that somewhere is a rich Artist Date.

Artist Dates provoke a sense of connection. In visiting something you love, you come home to yourself. There is a thrill that is quite visceral. A feeling of well-being steals over the senses. Many report they felt a touch of the divine. There is something sacred in celebrating what we love. A feeling of gratitude for the abundance of the universe is a common experience.

"Julia, I think I felt God," one student exclaimed to me with wonder.

The sense of a larger and benevolent something—call it God or not—is the frequent fruit of an Artist Date. On the dates, we are kind to ourselves, and that seems to raise for us the possibility of divine benevolence.

Ours is predominantly a Judeo-Christian culture, and many of us have been raised with a punitive God concept. Our childhood God is often judgmental and punishing. We must work to establish a more benevolent God consciousness. Our "new" God may be kind, generous, encouraging, even good-humored. As we list the traits we would like to have in a god, we may realize that those traits might actually be an accurate naming of characteristics that do exist. There is a truthfulness to naming a benign god. We can posit a loving god and then begin

to experience one. Artist Dates swing open a doorway to the divine.

As we consciously work to delight ourselves, we become increasingly aware of the delights existing in our world. Let us say we do visit a pet store and pet a bunny. Our wonder at the marvelous creature opens the door to our wonder with the world.

At their best, Artist Dates inspire a sense of awe. As we undertake a visit to something that enchants us, we open ourselves to still further enchantment. One delight leads the way to another. Initially an Artist Date may strain our imagination as we strive to find something wonderful—for fun and perhaps for free. With practice, Artist Dates gain ease. As we become accustomed to wooing our artist, we become more ardent. The dates cease being "work" and instead become filled with a sense of abundance. As the dates cause us to prosper, we increasingly inhabit a prosperous world.

ARTIST DATES BUILD one upon another. As we pursue a fancy, other fancies suggest themselves. Interests lead the way to passions as we become more and more committed to savoring our experience. If our dates begin as black and white, they soon assume Technicolor as they awaken our senses. Focusing on our senses becomes pivotal. One Artist Date to visit a rose garden awakens our senses of sight and smell. Another, to a restaurant with a good salad bar, wakes our sense of taste. The pet store with the fluffy bunny jump-starts our sense of touch. The concert opens our ears. Planning Artist Dates a sense at a time sets for us a meaningful challenge. As each sense is focused upon, it awakens. Fully awake, we experience ourselves as multisensory beings. All of life becomes more savory.

"Artist Dates woke me up," one student exclaimed. "Everything became more vivid. I feel more fully alive."

Feeling more fully alive is a common fruit of Artist Dates. It is as though our lives, like Stivers's animals, become saturated with color. We become alert. We notice the particulars in our surroundings. In New York, cherry trees surround the reservoir in Central Park. Their blossoms are a pink froth not to be missed. In New Mexico, spring brings full blooms to the apricot trees. Again, not to be missed. Each season—and each place—brings a passing glory, and we are awake to them all.

"Since starting Artist Dates, I pay better attention," another student explains.

It is as though taking an hour or so weekly to really focus on pleasure makes the other hours of our week more pleasurable. The fun of an Artist Date both precedes and follows the actual date itself. We look forward with anticipatory glee to the date we plan. Afterward, we savor the memory of the date. Our Artist Date has three distinct phases: before, during, and after.

Artist Dates make us more grounded. As we focus on pleasing ourselves, we learn what pleases us. A student complained to me that she found Artist Dates painful. A little exploration revealed that she was taking "serious" Artist Dates, focused on self-improvement. "Lighten up," I told her, and she did, reporting back happily that her dates were now a source of fun, not edification.

Ideally, Artist Dates are gleeful experiences. They are focused on fun, frivolity, and fancy. In other words, on sheer delight. Play awakens the imagination. We find our thoughts more fertile. We concentrate on fun, and we discover that we gain an increased ability to concentrate, period. It is as though our mind is rewarding us for having given it some relaxation. In return for fun, we receive an increased capacity for work.

Artist Dates make us realize that many of us have

lopsided lives: too serious and too focused on work. My mother kept a bit of doggerel prominently posted as a warning:

If your nose is down to the grindstone rough,
And you hold it down there long enough,
Soon you'll say there's no such thing
As brooks that babble and birds that sing.
Three things will all the world compose:
Just you, the grindstone, and your darned old nose.

My mother knew to take Artist Dates. In her fifties, she signed up for a course in belly dancing. Her graduation certificate enjoyed a place of honor in our household. With seven children to raise, she knew the value of sheer, unadulterated fun. Our house featured two pianos: one for lessons and one for fooling around. My mother played the piano herself, launching into "The Blue Danube" waltz whenever she was upset. From her example, we children learned that a dose of fun cures the blues. When we were too moody, Mom would load us into the car and take us on an Artist Date to the Hawthorn-Mellody Farm, a local dairy farm that featured a petting zoo. A visit with a baby lamb or goat always restored our good spirits. Baby animals sparked joy, and our grumpy moods vanished.

Artist Dates are an antidote for our woes. An hour, or even two dedicated to fun lifts the mantle of depression. Optimism sneaks into our temperaments. The whole world switches moods from sad to sunny. Taken once weekly, an Artist Date is a powerful prophylactic for despair.

"I found myself hooked after just a few Artist Dates," confessed a woman who had fought depression for years. Her Artist Dates became a happy habit.

"I resisted Artist Dates," a man confided. "When I

finally took one, I was astonished at the difference it made in my world view. The world went from threatening to friendly."

Artist Dates alter our perspective. Troubles that loomed large shrink in size. We find ourselves feeling stronger, able to face down our obstacles. Our sense of proportion returns. We become large enough to conquer all that we encounter. We feel strong where before we felt daunted.

Artist Dates are an integral part of the listening path. As we set out to have fun, we are voting confidence in ourselves. We are daring to expand. Listening for the joy that each festive expedition brings us, we become attuned to happiness, and happiness is a primary characteristic of the listening path.

◄ TRY THIS ►

Once a week, take yourself on a festive solo expedition. Do something that brings you delight. Choose something fun, something that tickles your fancy. Plan your date ahead of time so that you anticipate it with joy. Allow yourself to be playful. Be young at heart.

WALKING

When we walk, we listen. We tune in to the sights and sounds of our environment. We awaken our senses. Walking brings us into the present moment. We notice our surroundings. We become alert. Moving at a gentle pace, we take in all that meets our path: the cardinal flicking from a tree, the mountain aster gracing the roadside, the chamisa bush gone silvery-green, the quick gray lizard darting across our path. Stretching our legs, we stretch

our minds. We take delight in the songbirds perched in the piñon tree. If we are lucky, we spot a deer posing immobile in the tall grass.

Each step we take fires off endorphins: nature's booster rockets. Our body chemistry alters toward the positive. Our mood lifts automatically. What we see and hear cheers us as well. We receive double benefits, physical and psychological; both work on our behalf.

"There! The cat on the windowsill!" We greet the sight gladly.

"There! The puddle to be avoided!" As we walk, we are alert. We spot the dangers of the trail. The pace of walking makes that possible. Sounds come to us crisply: the raven's caw, the songbird's trill. We register each sound: the wind in the piñon trees. The softest swoosh catches our attention. We listen to our world as we walk.

"I love to walk," one woman reports to me. "I try to take ten thousand steps daily. I have a gizmo that registers each step. It is called a Fitbit, and I love it."

Walking with each step monitored gives us a feeling of accomplishment. Registering each sound, each step, we find the world friendly. It talks to us. The crunch on gravel of an approaching car—we hear it and are warned. The rumble of a large truck says, "Step to the shoulder." We hear our world as well as see it. In fact, sound often comes to us ahead of sight.

As we practice conscious listening, our hearing becomes more acute. We tune into the sounds in our environment. We become more and more discerning. With each footfall, we hear more clearly. We walk ourselves into clarity.

In the city, we pass a florist's shop—a kaleidoscope of color. Next, a bakery with savory treats gracing its window. A hardware store displays its wares. A bookstore shows its titles. Walking, we take it all in. Walking,

nothing is lost to us. Our mind and emotions capture the passing sights.

The florist's shop showcases orchids and bromeliads. The bakery features napoleons and croissants. A hammer and saw announce the business of the hardware store. Books propped to display their dust jackets clarion "Read me!" from a bookstore window.

Whether we live in country or in city, walking makes our territory ours. Whether we are spotting a painted horse grazing by the roadside or a mounted policeman directing traffic, we savor the sight. Walking, we take mental Polaroids, catching moment by moment. Back at home, settling in to write or paint, we have our memories of walking to draw upon. Walking has enriched our store of creative supplies.

Endorphins, nature's booster rockets, are released as we walk. Our feelings of well-being increase. Walking out grumpy, we alter our mood a footfall at a time. A brief twenty-minute walk is long enough to nudge us into optimism. We vanquish our bad moods with every step.

It matters little whether we walk in country or in city. An ambling pace guarantees we will take in enough sights on either route. Walking with a dog, we take in the dog's sights: "Oh, look! There's a handsome Rottweiler." "Look! There's a darling cocker spaniel."

My dog, Lily, a Westie, has a fondness for my neighbor's golden retriever, Otis. She yips with excitement when Otis is out in his play yard. We live up the mountain from Santa Fe, and our neighborhood sports deer. When Lily spots one, she stops stock-still. "That creature is *big*!" I can almost hear her thinking. It takes a tug or two on her leash to convince her to walk on. One morning she spotted not one, but four deer. She stood riveted as the deer crossed the path ahead of her. "What a good adventure! I can't wait to tell Otis!" her posture said. And stopping by his play yard, Lily did precisely that.

SOMETIMES PEOPLE HAVE difficulty setting out to walk. It seems like a waste of time and energy. But it is not a waste. A twenty-minute walk burns forty calories, sometimes more. It revs up our metabolism for several hours. A daily walk peels away pounds. It is enough to tone our muscles and build our stamina. "Walk daily," advises physical trainer Michele Warsa, herself the trim product of her own advice.

"Walking is the best," echoes actress and poet Julianna McCarthy. "All the authorities agree," she continues. "A daily walk takes off the pounds and has the added benefit of creative inspiration."

Among the authorities McCarthy numbers we find writing teacher Brenda Ueland. Herself a great walker and writer, Ueland proclaimed, "I will tell you what I have learned myself: For me, a long five- or six-mile walk helps, and one must go alone and every day."

Still another great authority is author Natalie Goldberg, who penned the classic *Writing Down the Bones,* a great into-the-water book and perennial bestseller. Goldberg vouches for walking as a primary creativity tool. Seventy and fit, she hikes to maintain her spiritual balance. "Walking gives me ideas," she tells me. "I like to limber up my mind."

I have been friends with McCarthy for forty years and friends with Goldberg for thirty. They are both believing mirrors for me, reinforcing my identity as a writer, and yes, as a walker. When my spirits flag, I phone both of them and get a booster shot of inspiration.

"It's good that you're walking Lily," McCarthy tells me, infusing me with her own love of walking. I tell her of the deer Lily spotted and she chuckles appreciatively. McCarthy lives up a mountain in California. We share flora and fauna reports from her mountain to mine.

Author John Nichols is yet another writer and walker. He credits his daily trek up a small mountain in Taos, New Mexico, with fueling his creativity. Like Brenda Ueland, he takes a long walk "alone and every day." The author of *The Sterile Cuckoo, The Milagro Beanfield War,* and a dozen other books, Nichols is good-humored—yet another benefit of his walks.

"John makes me chuckle," I recently confessed to Goldberg.

"Me too," she corroborated, having just shared a podium with him.

Like Nichols, Brenda Ueland waxed optimistic. She stated, "Think of yourself as an incandescent power, illuminated and perhaps forever talked to by God and his messengers."

She was talking about celebrating her "conscious contact" with a higher power. One of the first and finest fruits of walking is the sense of connection to "God and his messengers." As we walk, we experience a spiritual dimension. Hunches, insights, and intuitions come to us, ideas not our own. As we groove the habit of walking, we find ourselves cocking an inner ear to higher realms.

ALTHOUGH WE CAN quickly discover its benefits for ourselves, walking holds a place of honor in many spiritual traditions. Aborigines set out on walkabouts. Native Americans pursue vision quests. Wiccans walk to Glastonbury. Buddhists practice walking meditation. It was Saint Augustine who proclaimed "*Solvitur ambulando*"—"It is solved by walking." The "it" may be a personal or professional dilemma. Walking untangles our often tangled lives. A footfall at a time, we are brought to clarity. Søren Kierkegaard walked to unravel affairs of state. We might equally walk to unravel affairs of the heart. "I feel this way about that," the walks tell us. Many of us intuitively

take to walking when we are trying to puzzle something out. With each step, we listen—and "hear"—with more ease. As we walk, our listening deepens. We naturally attune to our environment and to our higher selves.

Walking, we take in the sights and sounds of the world we live in. In the country, we hear songbirds, their melody interrupted by a raven's caw. Walking slowly, we soon spot the raucous bird perched on a high tree limb. It flaps off as we draw near. We walk on, gifted again with melody.

In the city, a jackhammer drills a staccato beat. Walking toward the sound, we see that a stretch of sidewalk is being repaired. Skirting the men and machines, we come upon a hydrant gushing water. We step into the roadway, the better to avoid the muck. A taxi honks and we step to one side. The impatient driver shouts from a rolled-down window, "Out of the way!" "Okay, okay," we call back as, stepping up on the curb, we resume our walk, pausing to warn a dog walker of the mess he will face ahead. Walking renders us friendly. The dog walker, with his pack of dogs, thanks us for the heads-up.

"Sure thing," we respond. The din of the jackhammer drowns out further conversation. We walk on, leaving the hubbub behind us.

Making walking a conscious tool, we learn to listen to ourselves closely. The listening path is led a step at a time. Walking, we walk ourselves home.

I wrote a book titled *Walking in This World*. Its premise? That walking benefits us spiritually as well as physically. It suggests walking with friends, the better to have a heartfelt conversation. Walking, we are attuned to the rhythm of our thoughts. We hear the words and the emotion behind the words. We become intimate. It is difficult to lie, walking. Each footfall engages our attention. Each footfall engages our breath. We find ourselves saying the unsayable. We listen as we talk. We ask ourselves the

question, "Am I being authentic?" Walking as we talk, the answer tends to be yes.

◄ **TRY THIS** ►

Outfit yourself with a pair of comfortable shoes. Set out for a brief, twenty-minute walk. Take in your surroundings. Notice what you are mulling on. Back home, take to the page, and note down one sight from your walk.

For example: *I passed a florist's shop with a whole bank of giant sunflowers.*

Or: *I passed a shar-pei who looked very distinguished.*

Now, write down one aha from your walk. We receive insights and ideas when we walk; walking opens us to a higher form of listening, which might be called guidance or intuition.

For example: *I realized I can trust that my cousin has a higher power, even though she looks to me for so much advice.*

Or: *I'd like to write more music. I could write a little bit each morning after Morning Pages.*

Take your twenty-minute walk at least two times during the week. Are you waking up to the world around you?

LISTENING
TO OUR
ENVIRONMENT

———⚬⚬⚬———

Part of doing something is listening. We are listening. To the sun. To the stars. To the wind.

—MADELEINE L'ENGLE

The first step on the listening path is to listen to what we may be in the habit of tuning out: the world around us. This week you will be asked to tune into your environment. We will explore the sounds that surround us—those we enjoy and those we avoid. We will practice tuning in, so that we may connect—to our world, and to our relationship to that world.

WHAT IS YOUR SOUNDTRACK?

The listening path tunes us into our surroundings. Its first tool focuses on what we hear around us. We take the time to notice our sonic environment. Is it soothing or abrasive? Loud or soft? As we tune into the sounds around us, we take notice of what it is we'd like to change.

We are creatures of habit, and we can become habituated to some very unpleasant things. Our alarm clock may shrill for our attention. A little shopping trip would yield us a clock with a pleasant chime, but we tell ourselves that our harsh clock is no big deal, and so our days begin on a discordant note. Ditto for our microwave. It beeps "ready" and its beep, too, is discordant. No big deal, we tell ourselves, if we notice its sound at all. And so on, through our day, we are here, but we do not hear.

It is no mere pun to say we yearn for lives that are more sound. Our daily soundtrack can be consciously altered. The expenditure of cash for a lovely sounding alarm clock pays off handsomely as we wake to a more pleasant world.

Pay attention to the intricate patterns of your existence that you take for granted.

—DOUG DILLON

Sound by sound, we can move through our day, asking always, "Is this sound pleasant?" An astonishingly high percentage of our answers are no. Working to change no to yes, we find ourselves relaxing.

The ceiling fan makes an annoying tick-tick-tick that makes it difficult to hear on the phone. A trip to the hardware store for WD-40 is indicated. It's time for procrastination to end. The lubricant is not expensive. "Oiling" the fan puts an end to the ticking. A gentle whirr replaces the annoyance. Now it is easy to hear on the phone.

My friend Jennifer Bassey's pleasant voice comes through loud and clear. "You fixed that fan," she announces.

A stray scrap of paper flutters in the car's air conditioning. It's been there a long time, and you have learned to tune it out. Focused, now, you tweeze the paper from the breeze. The car is suddenly more pleasant. The engine hums steadily, without the erratic fluttering you've grown accustomed to.

What's this? As your car pulls out of the driveway, your ears pick up the sound of laughter. The neighbor's children are shooting baskets in their driveway. You can hear the kerplunk of the ball as they dribble. You can almost hear the swoosh as the ball passes through the net. Above all, their joyous laughter signals that fun is at hand. Your spirits lift with theirs. The sound of joy—or the sound of sorrow—calls us to respond in kind. We hear a child sobbing and we are moved to compassion. A child's giggle moves us to joy. Although we are seldom aware of it, a soundtrack accompanies our daily rounds.

Listening is receptivity.

—NATALIE GOLDBERG

Driving to work, we are annoyed by the honking of an impatient driver. "Easy does it," we may think to ourselves, consciously tuning in instead of tuning out. At lunch, gently attuned to the sounds around us, we may perk our ears to the sound of cathedral bells marking the hour. They chime again as we are leaving the office, having

worked late. Once at home, we may cue up a favorite album, relaxing to the sound of Native American flute music. We purposely choose it for its gentle and hypnotic melodies. My perennial favorite is an album called *The Yearning* by composer Michael Hoppé. It features the virtuoso alto flute of Tim Wheater.

Gentle sounds make for gentle lives. As our kindly sounds sooth our psyches, we become more kindly. Rather than acting abruptly, as harsh, staccato sounds seem to demand, we respond, rather than react, and we respond tenderly. As we take in the sonic environment that speaks to our heart, we are able to forge more heartfelt lives. As we soften the tone of our lives, we soften our responses to the world around us. No longer harsh and staccato, our lives become gentler.

An evening spent at home can be made far less lonely with the addition of a pleasant soundtrack. Music soothes the savage beast, and it soothes us as well. A favorite selection changes the quality of our life. Our mood loses its jagged edge.

Sound healing is the specialty of the late Don Campbell. His book *The Roar of Silence* is a classic in the field. His later book, *The Mozart Effect,* argues persuasively that music impacts not only our mood but also our IQ. Children exposed to Mozart are happier and brighter, he posits. A sampling of Mozart also makes for better-tempered adults, he asserts. As John Barlow states, "Take seriously the idea that music can represent emotional states. Liberate your body in this world and save your soul in the next."

Music lifts us to higher realms. Musicologists tell us that music is our highest art form, drawing its listeners closer to God. Undeniably, listening to certain music is a spiritual experience. Handel's *Messiah* lifts the listener into sacred realms, delivering a spiritual experience as well as an aesthetic one. Pachelbel's Canon in D soothes

It is a beautiful symphony: the sound of the typewriter keys on paper!

—AVIJEET DAS

the soul. It is profoundly reassuring. Franz Schubert's "Ave Maria" is spiritually opening. It soars and invites the listener to soar with it.

On the listening path, music is an indispensable ally. As we become conscious of its far-reaching effects, we can program our listening delight. Becoming alert to the impact of sound, we can choose music to alter our mood. Drum music is journey music, and it opens a doorway to the divine. Mickey Hart and Taro give us *Music to Be Born By*. It is propulsive, energizing, and grounding.

Flute music is a companion in our loneliness. David Darling and the Native Flute Ensemble gift us with *Ritual Mesa*—a haunting collection of heartfelt melodies. The full swelling of an orchestra invites an upsurge in our own emotions. Beethoven's Symphony No. 9 and the *Fidelio* overture wax exultant. The cleverness of Bach's *Goldberg Variations* wakes up our mind. As we listen, we learn.

Listening, really listening, casts us into the present moment. We become mindful of each note as it unfurls. Spiritual teachers unite on the importance of "staying in the now." Revered Buddhist teacher Thich Nhat Hanh writes eloquently of the many benefits of staying focused on each moment as it arises. He uses the Buddhist term "mindfulness," although I might suggest a more ecumenical term: "heartfeltness." When we listen to each moment as it unfolds, we find ourselves listening to our heart. We listen without, and we listen within. Thich Nhat Hanh gives the example of sipping a cup of tea "mindful of its goodness," but it is our heart that experiences gratitude. The tea is good and we feel good drinking it. We are in the moment.

Too many of us live our lives pell-mell. We rush from event to event. We feel that velocity is our friend, but is it? When we slow our pace, we find our lives unfolding at a comprehensible rhythm. We hear ourselves think. The

She said the music made her wonder, Does it alter us more to be heard, or to hear?

—MADELEINE THIEN

listening path demands we pay attention. We must listen to the sound of our lives if we are to live sound lives.

Stop and listen. The story is everywhere.

—THOMAS LLOYD
QUALLS

◄ **TRY THIS** ►

For one day, keep a log of your soundtrack. Begin with the buzz of your alarm clock. Ask yourself, "Is this sound pleasant or abrasive?" Keep this thought in mind as the timer beeps on your coffee, as your microwave signals that your breakfast bowl of oatmeal is ready. Note the clatter of the subway as you head to work. If you drive, pay attention to the honking horns. Ask yourself, "Could I take a different, less hurried route?" Notice the hubbub of the diner where you routinely eat lunch. Is there a quieter alternative? Continue through your day noting sounds and your reactions to them. At day's end, jot down your discoveries. What changes could you make to make your auditory experience more pleasant? Be gentle on yourself. Treat your ears with loving care.

TERRIERS BARK

"What if I can't control the sounds around me?" my students sometimes protest. "What if I've learned to tune them out, out of necessity?"

Tuning our sonic environment out puts us in the habit of detaching instead of connecting. I would argue that tuning out take more effort than tuning in, where we can explore our solutions. Tuning in puts us into the position of awareness, and from awareness, we can create change—or we can try.

Case in point: My Westie, Lily, has a deluxe dog yard, featuring rolling hills, tall trees, and flowering bushes.

Stone paths curl around the flora and fauna, and a large deck leads back into the house via a dog door just big enough for a small terrier. My property is surrounded by fencing, and from Lily's perspective, the vast domain is her own personal paradise, where she is free to roam and explore. This is true, but what is also true is that the land just on the other side of the fence belongs to my neighbors. And Lily is a barker.

It is almost nine P.M. I have closed the dog door and Lily is frustrated. She sits by the door, softly woofing. If I let her out, she will engage in full-scale barking, and my neighbors will be annoyed.

Adopt the pace of nature: her secret is patience.

—RALPH WALDO EMERSON

"Lily, hush," I tell her. My colleague Emma tells me that dogs have very large vocabularies, and that they understand when we speak to them. But "hush" goes ignored. If Lily understands, she is rebelling. I have a few phrases she clearly understands. To wit: "Lily. Salmon. Treat," and then, "Okay, that's enough," and "See you later," and finally, "Bedtime."

It's not "bedtime" yet, and so Lily registers her displeasure at my behavior. I resolve not to give in. The boundary has been set: no barking. If Lily is stubborn, so am I. A dog trainer once told me, "Terriers are barkers. They're territorial." Another trainer said ruefully, "We trainers can't do much with a terrier." And so I try to accept that Lily isn't being obnoxious; no, she is simply being true to her terrier nature.

Lily jumps to the back of the loveseat. There, perched alertly, she continues to woof her disapproval. "Lily, hush," I again scold her. Tiring of the game, she abruptly sighs and climbs down from her perch to lie stretched out.

I am seventy-one years old, and I monitor my behavior, lest I be turning into a dotty old lady who talks to her pet more than to people. But Lily is talking back. She suddenly leaps to her feet and starts barking—a

loud, "outdoor" bark, even though she is indoors. "Ruff, ruff, ruff!" Her bark is loud and guttural. Something has her riled. I look out the window to see what's what. Her dog-yard fence is seven feet high, too high for a coyote to scale. It effectively deters bears and deer. Skunks and possums can master it, though, but neither creature is a welcome visitor. I press my face to the window and then see not one skunk, but two, walking the dog-yard fence like circus acrobats, balancing with their snowy-striped tails. Lily is barking aggressively: "Let me at them!" but I am happy—and relieved—to have her trapped inside. One small terrier is no match for two huge skunks, her bravado notwithstanding.

I want to sing like the birds sing, not worrying about who hears or what they think.

—RUMI

"Lily! Salmon! Treats!" I pad to the refrigerator hoping to distract her and stop her barking. But Lily is, as I've said, stubborn, and just now she is stubbornly focused on the skunks.

Ten minutes, twenty minutes, a half hour . . . her barks are growing hoarse. My nerves are matching them. I worry that her barking is loud enough to disturb my neighbors, even from inside the house. I have promised them she will be quiet after ten, and it is now nine fifteen. Lily gives no sign of stopping.

I go back to the refrigerator and take out a package of salmon—gravlax, Lily's favorite. I cross to Lily and wave the succulent treat near her nose. Eureka! She stops barking and grabs the salmon ravenously. So much for a slice at a time.

"Good girl, Lily," I tell her, hoping her vocabulary is indeed large enough to register the phrase. I use my most soothing tone. I retreat to the loveseat and Lily, treat notwithstanding, retreats to the dog door, where she sets about woofing. We are back to square one, but her woof is softer than her full-scale barking. It's nine thirty. We have beaten her curfew by half an hour. I press my nose to the window. Blessedly, the skunks are gone.

"Lily. Bedtime." Reluctantly she abandons her post and follows me to the bedroom.

> **◄ TRY THIS ►**
>
> Quickly jot down three sounds in your environment that you can't control. Tune into each of the sounds. Do they make you frustrated, anxious, nervous? Is there anything you could do to try to change these sounds? If not, could you avoid them? Allow yourself to consider the possibilities beyond "tuning them out," and see if you don't find yourself feeling more empowered—and more free.

Half the time you think you're thinking, you're actually listening.

—TERENCE MCKENNA

HEEDING OUR ENVIRONMENT

Our sonic environment is fascinating, and when we choose to listen to it, we will find that it is filled with information. One of the simplest ways to practice heeding our environment is to listen to the ever-changing climate around us: the weather. Today I resolve to do just that.

The poetry of the earth is never dead.

—JOHN KEATS

There's just enough time for a walk, so I snap Lily's leash to her collar and trot her to the door, where I set the alarm. Alarm on, we slip out. The air smells of ozone; a storm is on the way. Not here yet, but pending.

"This way, Lily," I coax, setting out down the mountain on our shortest loop. Lily tugs on her leash. She wants to go faster. I tug back, not wanting to hurry. A peal of thunder sounds over the mountains to the east. I give in to Lily's urgency. If we hurry, we will just have time to execute the loop. Lily is determined to sprint. I trot after her until we reach the halfway point, the turnaround.

"Home, Lily," I announce, and I head back up the mountain. After a moment's balking, Lily follows suit. A

second peal of thunder sets us to jogging. We hurry toward home. At the moment, it's a good day for walking, cool and breezy. Thunderheads balance on the peaks but do not roll down. Lily takes to the road, scattering two lizards who block her way. Lily is fast, but the lizards are faster. They zip under a rock, a dark hiding place safe from Lily. She sniffs hungrily where they've gone.

"Come on, girl, let's stretch our legs," I coax, giving a tug on her leash. Reluctantly she abandons her hunt. I wonder if lizards are a dog's version of escargot. Now we are climbing back up the mountain. As we near the end of our dirt road, a sudden breeze swoops down on us. Lily stops to sample the scents carried on the wind. I wonder what she is picking up. Deer? Bear? Coyote? She woofs a worried woof, encountering something wild on the wind. Her alert attention makes me uneasy.

"Come on, sweet pea. Home." I put on my most stern tone. Lily darts to the end of her leash. She tugs me to go faster. She knows "home."

Entering my courtyard, she jumps up to the garden, sniffing at the proud lilies, getting a muzzle full of orange dust. A rare striped lizard ducks beneath the lavender bush. Lily ignores it. Her taste in lizards is the common gray.

"Salmon, Lily!" I coax my little dog to abandon the garden and come inside. I see the tug-of-war in her thinking. "Garden? No, salmon!" Salmon it is. She rushes past me to the refrigerator. I open it and reach inside, peeling off a strip of wild Alaskan smoked salmon. Lily rears on her hind legs, the better to capture the treat. I hear another roll of thunder. I feel smug. We got our walk in in between storms. More thunder rolls in the distance. Storm clouds descend from the mountain peaks. I light seven-day candles and perch them on tabletops. I locate strong flashlights and place them within easy reach. Yesterday my power went out for hours. Outages are

common here in the mountains. Today I am prepared, although I dread a night of darkness. Lily hovers near my feet. She is frightened by the impending storm.

Storms in New Mexico are dramatic. The roadways flood. Rain comes down in great sheets. Drivers pull to the side of the road, hazard lights flashing, as they wait out the rest of the storm. Flash-flood warnings light up our cell phones. Torrents turn the dirt roads into rivers. The paved roads have puddles half a foot deep. Those foolhardy drivers that dare the storm drive toward the center line, unable to make out their own lane.

Safe at home, I listen to the tattoo of rain on the roof. It pours down the portal. Lily gives a worried "woof" as thunder booms closer. A large bolt of lightning illuminates the garden. The lilies stand upright, facing down the torrents that bend the rosebushes. I am surprised by the lilies' strength; I think of them as delicate. Not so.

Lily is hiding under the living room coffee table. The rainstorm is pelting the roof. The drops make sharp pings. Lily hates the sound. A roll of thunder adds to her discomfort. She crosses to my side, seeking company and shelter. Another peal of thunder makes her shiver. Lightning creases the sky. It's a full-fledged electrical storm. Thunder rolls again.

Living with Lily, I have grown accustomed to her many moods. Weather—anything other than bright sunlight—sets her off. Snow, sleet, hail, rain—they are the enemy. The house is full of hiding places: under the coffee table, behind the coatrack, under the covers on my bed. If a storm is particularly bad, like this one, Lily croons to herself, a soft moan that offsets the thunder.

The storm is pelting stronger. Lily eddies at my feet. Suddenly she notices a moving spot. A lizard, probably having gained entrance through the dog door. Lily pounces. The lizard skitters away. Lily pounces again. Again the lizard escapes. This game could go on for

hours. Blessedly, it distracts Lily from the storm. But I know the game will end with the lizard's death. I can't stand to watch. I retreat to another room, and only when silence reigns again do I go check.

Yes, the lizard is dead. Lily has lost her playmate. Still spooked, I gingerly, tenderly gather the dead lizard and put it into the trash.

The storm is a big one. Rain pelts the roof. It rains through the night and I sleep poorly. I keep one flashlight illuminated. Dawn brings with it a break in the rain. The lilies still stand sentinel. The roses bow their wet heads. The world has taken a battering.

How often have I lain beneath rain on a strange roof, thinking of home.

—WILLIAM FAULKNER

THE NEXT MORNING, the dirt road leading to my house is a sea of mud. I won't walk Lily. I try to explain to her, but she wants to go, mud notwithstanding. I promise her we will walk later, once the mud dries. The storm spits a few final drops. When it stops, Lily goes to the dog door, perhaps looking for more lizards. She goes out on her hunt. And when she comes back in, it is with a piece of kindling in her mouth. It is not as good a treat as a lizard, but it tastes good enough that she settles in for a good, long chew.

It has become a calm day. Lily abandons her piece of kindling, leaving the chewed-up shards on the rug. She hunts the house for lizards, but there are none to be found. She settles down behind the coatrack. When I call her name, she is reluctant to come out. Perhaps her hiding is a strategy. If she is quiet, perhaps a bold lizard will cross her path. She can hope.

I am brewing a strong pot of coffee. The coffeemaker bubbles and hisses. Its sound reverberates through the lizard-less house. Lily ventures out, padding into the living room. She scrambles up next to me on the loveseat, stretching out for a nap. When I pat her silken coat, she

shrugs me off, annoyed. She has given up on lizards and wants to snooze.

Making my way to the kitchen, I turn off the coffeemaker. Now the ticking clock is sharply audible: tick-tick-tick. I pour myself a mug of coffee. I take over from Lily the job of lizard hunting. I am hyperalert, straining my ears for the telltale "scratch-scratch." The mug of strong coffee jangles my nerves, making the appearance of another lizard seem likely. I tell myself lizards are harmless, but the coffee has me on edge. And, too, the wind is picking up. Once again, the piñon tree lashes against the window. Lily stirs from her nap. She doesn't like the wind. Again, she hides behind the coatrack, this time focused on the nasty wind.

"It's so quiet here," visitors to my house frequently comment.

"Not on a windy day," I respond.

My house is set back from the road. "Hear the truck?" I ask, but my visitors hear only quiet. Their ears are not attuned to the approaching vehicle. My focused time on the listening path has made my hearing more acute.

There's a lot of difference between listening and hearing.

—G. K. CHESTERTON

I WAKE UP early, with the sky just lightening to the east. It rained again during the night, and now the pale sky grows dark again. Lily paces the floor nervously. Storms make her agitated, and this storm, with its sudden crack of thunder, is worse than most. Summer hailstorms in New Mexico are surprising and extraordinary. Lily hovers by my side, needing reassurance.

"It's okay, Lily," I tell her. But we are in for drama. A second strong crack of thunder announces a surprise. With a sound like snare drums, tiny ice bombs pelt from the sky. I find the sound of the hail to be reassuring, but Lily does not. My house has huge windows, and Lily avoids looking out.

"It's just hail, sweetheart," I tell her. I appreciate the windows with their birds-eye view of the storm. As I watch, the hail coats the garden with silver balls like tiny marbles. A third crack of thunder tells us that the storm is still not spent. I cross to my largest window and watch, rapt, as the storm deposits its shiny cargo. Hail, to me, is more mysterious than rain, more miraculous than snow. Lily refuses to be enchanted. She hides under the living room coffee table. And then, as suddenly as it started, the drumroll of hail abruptly stops. Lily is not convinced. I have to coax her out, scooping her up in my arms. The window out to the garden offers a good view of the storm's deposit. I hold Lily to the pane.

"No danger," I tell her. She wriggles, then settles against my chest.

"No danger," I repeat in my most soothing voice. Together, we stare out the window. The storm's silver blanket will soon begin to melt.

"Hail, Lily," I whisper. We both curl up on the loveseat, taking pleasure in our companionship. I look out the large window toward the mountains. A shaft of sunlight lights the peaks. Peering out another window to the garden, I see glistening chunks of ice. But no new hail is falling. The kitchen clock is suddenly audible.

Twilight comes on darker and earlier than usual. I am headed to town to meet with friends. As I get into my car, a few heavy raindrops fall, speckling my windshield. I back out of my driveway to a steadily increasing drumbeat. This is no mere rainstorm, but a steadily increasing crescendo. Hail the size of ice cubes again pelts down from the heavens. It is as if higher forces have grabbed a gigantic ice tray and are giving it a celestial shake. As I pilot my car onto the highway, the hail grows in size and velocity. Ice cubes become snowballs. A quarter of a mile from home, I make a decision to turn back, hoping to make it safely to the shelter of my garage. The storm

is strong, an onslaught, and I am worried that my windshield will shatter.

I turn into my driveway, activate the electronic door, and nose my car into the garage. My alarm is shrilling: the hail set it off. I punch in the code twice. The shrilling stops. Lily rushes to meet me at the door. The return of the hail has frightened her.

"It's okay, girl," I tell her. Unconvinced, she hovers near my legs. I cross to a window and peer out. The hail is scattered like billiard balls. Chunks of ice roll across the patio. There is a steady roar.

"My poor garden," I think. I look out the window and discover my garden white with ice. My lilies still stand proudly. My battered roses droop. My irises are taking a battering. My lilac bush bows its head, bludgeoned.

Lesson learned: if raindrops sound extra heavy and loud, hail is on the way, not rain. In the future, I will not try to drive out. A hailstorm can be vicious: not marbles of ice, snowballs of ice slamming to the earth. My phone shrills. It is one of my friends canceling dinner, reporting that he was out on a walk with his wife when the hail struck. A passing car took mercy on them and picked them up—salvation in the kindness of strangers.

The next morning, the sun shines down on my property. The ice is gone, as if it had never existed. I call my friend Nick Kapustinsky, and we arrange to meet for lunch. Driving down the mountain into town, I mourn the battered trees. The hailstorm has pummeled the fruit trees, turning their delicate blossoms from pink and white to brown. "Maybe next year the trees will fare better," I tell myself. This year the trees are victims of the hail. I feel guilty recalling my enjoyment of the storm. Its silvery blanket proved murderous. Lily had been right to fear the onslaught.

Turning west on a busy road, I pass a stand of forsythia

To pay attention, this is our endless and proper work.

—MARY OLIVER

bushes. Yesterday they were bright gold, but the hail has had its way with them, and now their golden coats are tarnished. But what's this? A bank of lilac bushes flares proudly purple. The hail hasn't conquered them. Next, I spot a crab apple tree still in radiant bloom. I formulate a theory: purple blooms can withstand hail. I recall that in my garden, purple irises pierce the air. Perhaps my theory is accurate, I muse. Regal purple holds sway.

Heading west past more lilacs, my theory of survival of the fittest meets the acid test. A carefully planted little grove of apricots and pears are stained brown, while nearby, a scattering of crab apples retain their purple hue. The apricot trees look bruised, while the crab apples look vibrant. Hail is a villain. I know that when next it hails, I will greet the onslaught with mixed feelings.

Nick and I meet at a favorite spot: the Santa Fe Bar & Grill. Meals there are always tasty. Over steak tacos and blue corn vegetable enchiladas, Nick reports that he braved the hailstorm foolishly to throw a tarp over his car to prevent its being dented.

"I was lucky," he reports. "If any of that hail had hit me on the head, I'd be bleeding."

"You were lucky, indeed," I tell him, thinking how vulnerable he really was, despite his machismo.

The hail has gone now, but it has left me rattled. Like the tornadoes of my childhood, it was fierce and unpredictable. My windshield survived the storm, but the hood of my car has dents—round circles, punched in.

"I'll bet you can pop them out," Nick tells me. And then, "Maybe not. My tarp may have actually helped. My car is dent-free."

I tell Nick that the hailstorm has left me edgy, and my little dog, too.

Nick grins. "Edgy? My cat is edgy. He was outside when it began, but then he came rushing in, looking at me like, 'What's this? Fix it.'"

Faith is the bird that feels
the light and sings when the
dawn is still dark.

—RABINDRANATH
 TAGORE

"Yes," I think to myself. "That's it exactly." Hail is an act of God—humans can't fix it.

It is one of the marvels of New Mexico that as quickly and savagely as storms come, storms pass. Wind comes and goes dramatically. Humidity doesn't linger, and the mud dries fast. Hail transforms the world into an icy wonderland, but by the next morning, it is just another hot summer day, the only remnants of the storm the battered trees and my dented car. Once I'm back at home after lunch, Lily retreats to my study, curling up on the couch and quickly dozing. I nab a spot next to her and record the weather of the last days: clear, then cloudy. Rainy, then hailing. Icy, then sunny. I recall the sounds of the hail the size of quarters pelting down, loud and metallic. Lily sleeps through the tumult of my memory as I listen back to nature's many sounds.

◄ TRY THIS ►

Take pen in hand and write out a weather report. Is it clear, foggy, sunny, raining, something else? What impact does the weather have on your environment? On your mood? Do you find yourself "under the weather" or "in a sunny mood"? Record the sounds of the day.

ASPEN

The listening path puts us in touch first with the sound of our environment, and then with our environment more deeply. We may stop and listen to the rustle of leaves in the tree above us, and then, listening, look more closely. The listening path is about connection, and we connect to all that is around us.

Summer has turned to fall, and the leaves in New Mexico are showing off, turning from bright green to shining copper.

"Come along, Lily. Car." Lily jumps up into the back seat of my Subaru. She settles comfortably onto a sheepskin throw. I back the car out of my garage, explaining as I do to Lily that we are going to climb a mountain road up to the aspen groves that gleam golden in the afternoon light. "It will be scary," I tell her. "Lots of curves."

With that, we set off. I roll out onto our dirt road. I head up the mountain, and then make a sharp turn right, and then another left. I am suddenly on a paved road, heading down the mountain toward town. My car, a dependable Subaru, purrs down the incline. The paved road, the Old Taos Highway, runs parallel to the interstate. A tall brick wall separates the two, but the wall does little to diminish the sound of speeding traffic mere feet away. On the interstate, semitrucks rumble past, delivering groceries. Sedans and SUVs speed past them. On the interstate, the speed limit is sixty-five miles per hour. That's on the far side of the wall. Fifteen miles per hour on mine. I crest a hill and the two roads separate. Now I am allowed forty miles per hour. The roar of the interstate grows dim.

Up ahead, a traffic light announces we are entering urban traffic. The signal marks both left turn and right. Old Taos Highway dead-ends into the flank of the Santa Fe county post office. Horns bleat and blare. We pass through the noise of the city, heading over a canyon and up another, larger mountain. The curves come as promised. The speed limit is sometimes posted at ten miles an hour. I drive, obediently slow, much to the annoyance of a Lexus behind me. Whenever the speed limit is raised, the Lexus honks at me to hurry up. Finally, fed up with my pace, the Lexus takes advantage of a brief straightaway to pass me. It speeds out of sight.

Listen to the trees as they sway in the wind. Their leaves are telling secrets. Their bark sings songs of olden days as it grows around the trunks. And their roots give names to all things. Their language has been lost. But not the gestures.

—VERA NAZARIAN

I'd rather learn from one bird how to sing than teach ten thousand stars how not to dance.

—E. E. CUMMINGS

"How are you doing, Lily?" I ask my little dog. She is snuggled into the sheepskin, with her legs braced to navigate the curves. We climb a curve at a time, higher and higher. We climb past juniper and piñon, past a grove of birch trees, until we take a final curve and are suddenly in a bright gold stand of aspen.

"Aspen, Lily!" I announce. They are lit like candles, golden flames reaching to heaven. We bask a few moments in their glory. A brisk breeze stirs the leaves. A few flutter to the earth—a golden shower. I admire the beauty. Then we head down the mountain toward home.

"Quite a sight, eh, Lily?" I inquire, talking more to myself than the little dog. Living alone, I have made a habit of canine conversation. Lily's vocabulary is extensive, or so it seems. "Salmon" gets her rapt attention. "Treat" sends her scurrying to the kitchen for her lamb lung fillet. Emma insists that she understands "car." And now "home," a word and concept she knows from our walks.

"Home, Lily," I announce, pulling into the garage. She is reluctant for the ride to be over, so I heft her to the floor and ask, "Salmon?" She skitters to the door to the house. I open it and pass into the kitchen. Opening the refrigerator, I peel off a slice of smoked salmon. She licks my fingers in gratitude.

Tick-tick-tick. The kitchen clock marks time. I can hear it from the living room, two rooms away. Lily's tags tap against her water bowl, and I hear her drinking deeply, drowning out the clock's tick-ticking. It is a dark night with no moon visible. From my garden I can just make out the pinpoints of stars, reminiscent of the glittering leaves we saw today. I feel myself supported by the greater world, encouraged by how much a seemingly small adventure can increase my sense of connection.

◄ TRY THIS ►

Take a deliberate adventure to consciously connect with the world around you. Whether it is in the city or the country, in the mountains or on the coastline, tune into the sounds—and then the environment— around you. Do you feel a sense of connection with the world at large? With nature? Take a moment to jot down any insights that come to you as you make an effort to consciously connect. Reaching out to the world around you, do you sense that the world is reaching back? Do you feel your awareness heighten? Notice this sensation, and allow it to stay with you as you reenter the dailiness of your life.

THE SOUNDS OF LILY'S WALK

Snow caps the mountains. Down below it is still warm; no winter coats needed. My muddy roads have dried, but Lily still steps gingerly. I do, too. I wear a new pair of shoes.

"Come, Lily," I urge. She has paused outside Otis's play yard. Yesterday Otis ran free, chasing a Frisbee. Today he is penned. "Come along, Lily," I urge again, but she is determined to greet Otis, perhaps flaunting her relative freedom: the length of her leash. "Lily! Here!" I give her leash a sharp yank. A car is looming near. Sensing danger, Lily is obedient. She eddies by my side. With a friendly wave, the car passes by. Above our heads, a raven caws. It is perched on a telephone pole, and it is determined to stay there. Lily stops in her tracks. She hears the raven, but doesn't see it.

"Come along, Lily," I nudge.

A second raven flaps to the top of the pole. A second raucous caw captures Lily's attention. She digs in

Listen with your eyes as well as your ears.

—GRAHAM SPEECHLEY

her paws, alert but frustrated. Our walk today is punctuated by pauses. A rabbit veers into sight. Lily gives chase, straining to the end of her leash. The rabbit is as big as Lily herself. It darts into the underbrush, thwarting Lily. I tug again at her leash. After all, on this walk she is intended to be my companion.

A pair of doves perch on a phone wire. They stay stock-still as we pass under them without incident. They feel safe at their altitude. Lily trots by my side, resigned now that I am the leader on our walk. We are passing a patch of meadow where we recently spotted deer. Lily is alert, ready for another sighting, but we see no deer today. Our ravens and the rabbit are the fauna du jour.

◄ **TRY THIS** ►

Allow yourself to imagine hearing the sound of a car crunching gravel. Tug on an imaginary leash, pulling your pet to your side. Notice how clearly you can "hear" the sound of the automobile approaching. Take time to appreciate your sense of sound. Link your imagination to concrete recall.

CHECK IN

Have you kept up with your Morning Pages, Artist Dates, and Walks?

What have you discovered in consciously listening to your environment?

Do you find that you feel more connected to the world around you?

Name one memorable experience of listening. What was the aha that came from it for you?

LISTENING
TO OTHERS

———⊶⊷———

It takes a great man to be a good listener.

—CALVIN COOLIDGE

This week we will build upon the habit of listening to our environment and begin to consciously develop the habit of listening to others. We may become aware of a habit of interrupting or of thinking of our response while another is talking, instead of really listening. Or we may find that we listen too much without responding—or that we listen to those we should not. No matter how good a listener we believe we already are, it is possible to listen more closely to those around us. When we do, the insights our fellows will offer are always surprising and unexpected. When we listen to others, we connect to others. In the section that follows, I write about listening—but I also listen to those who listen well. Their insights add to mine.

THE MUSIC OF CONVERSATION

The second tool of the listening path asks us to listen to others, to tune into what they are actually saying, taking in their words and their intentions. We are asked to listen fully, to register the emotion, the tone and pitch of what is being said. We are asked to register the mood of the speaker, to correctly interpret the message being conveyed.

"I'm fine" can be said with sincerity or sarcasm. The tone carries as much information as the words themselves. "I'm fine" may mean just the opposite. It's up to us to decide. Reporting in on the state of our health, "I'm fine" may be accurate or filled with denial. Often we

The most basic of all human needs is the need to understand and be understood. The best way to understand people is to listen to them.

—RALPH G. NICHOLS

The most effective way to show compassion to another is to listen, rather than talk.

—THICH NHAT HANH

must check in with our intuition to correctly interpret the statement.

Two kinds of listening are required: inner listening and outer listening; listening to ourselves and to the others.

Genuine conversation requires both forms of listening. Without intending to lie, a speaker may gloss over more difficult feelings. "I'm fine" becomes the socially acceptable bromide. As the listener, it is up to us to dig deeper. A softly stated query—"Really?"—may lead to more exploration and revelation. Ruefully, the speaker may admit that they are not perhaps fine. To the contrary, they may be under siege by difficult emotions. Our alert attention to their tone issues an invitation for candor. The resulting conversation has more depth and truth. Our alert listening opens the doorway to true intimacy. It leads us to questioning, not in a combative tone, but in a tone of genuine inquiry. We want to know, *really* know, the other's thoughts. Such attention is flattering and leads the way to authentic communication. Our attention invites attention in return. The listening path can be contagious. When we truly listen to another, the other may follow our lead by truly listening to us. In an atmosphere of such attentive listening, we find ourselves moving ever deeper into more candid and intimate revelations.

Listening is done with more than our ears. We hear words, but we must attune ourselves to our partner's tone, striving to capture the intention beneath the words. Using our intuition, we may discover a very different message than the words convey. Take the matter of health. "I'm doing well," our partner may say, but the tone says that "doing well" covers a multitude of possibilities—among them, "not so well." Listening with our heart rather than our intellect, we are able to capture our partner's truth. Listening with our heart, we practice empathy, the secret ingredient in true understanding.

Sometimes it is body language that speaks most clearly. Once again, the words may say something, while our alert attention tells us quite another thing. Shoulders slumped signal "sad," while the words may again assert, "I'm good." Arms crossed frequently signal a closed mind, despite words to the contrary. Fight-or-flight body language tells us true feelings. As we listen to our partner's body language as well as to spoken language, we discern reality with accuracy. We are not misled by superficial talk. As we listen to their whole body, our whole body signals to us. Faced with unspoken anger, our stomach may clench. Fear tightens our chest. Our throat may close over undisclosed woes. We are an antenna.

Listening is a two-way street. We listen closely and we invite listening in return. As we pursue the listening path, our contact with others becomes deeper, less superficial. We become more authentically ourselves, and others often do likewise.

We signal our attention by our respectful silence and by our murmured encouragement. We don't speak; that would cut off our partner. Instead, by our receptivity, we egg our partner into further disclosures. A whispered "mm-hmm," and a nod of the head telegraph our interest. Conversation becomes electric when fueled by such encouragement.

The listening path is active, not passive. We are like catchers on the ball field, crouched and ready to field a pitch. We are alert, responsive, ready. We allow our partner to lead, to initiate, to pitch. We keep up, but we do not take over. Instead, we practice the listening path by following. Our alert attention is flattering. We gently tempt our conversational partner into making deeper and deeper revelations. We are pleased by their candor, which we will match when it is our turn to share.

We teach by example. As we witness others, we show them our respect. Sensing our genuine interest, they often

Listening is not merely not talking, though even that is beyond most of our powers; it means taking a vigorous, human interest in what is being told us.

—ALICE DUER MILLER

engage more deeply—and often at a level that is frankly refreshing. Small talk is set aside in favor of meaningful exchanges. Monologues give way to dialogues. Sharing becomes more evenhanded. As we partner others through our listening, we may find ourselves partnered in return.

Our body language signals our goodwill. Arms open rather than skeptically crossed, we invite revelations. We listen with our whole body, and our physical openness speaks volumes. Partnered by such alert attention, our conversationalist soon relaxes. Soon enough, their body language matches our own. We give them cues indicating our receptivity, and they may respond in kind—monkey see, monkey do.

Friends are those rare people who ask how we are, and then wait to hear the answer.

—ED CUNNINGHAM

"I know how you feel," our posture indicates. We are listening with empathy, a step closer in than compassion. "I feel what you feel," we signal, or may even say. Responded to with such care, even the most narcissistic talker may interrupt himself to say, "I'm talking too much, aren't I?" Our shrugged assent may then steer the conversation off the shoals of self-involvement into the deeper waters of genuine sharing. Hunched forward to catch every nuance, our body is a radio kit set to "receive." Time enough, soon enough, to switch the dial to send. Our listening is a prelude to our speaking. As we listen deeply, our thoughts gather clarity and force.

"A good listener intentionally leaves space for the other to speak," posits Dr. Scottie Pierce, herself a good listener. Conversations with her are punctuated by meaningful pauses. She gives the impression she has all the time in the world. This allows time for her partner to speak clearly and carefully.

Nick Kapustinsky, actor and writer, chooses his words with care. "Good acting is about good listening," he says. Like Scottie, Nick's speech is punctuated by pauses, during which time he is fully focused on his partner. He listens, then responds. He "stays in the moment," as his

actor's parlance phrases it. Conversations grow deep, yet stay grounded. They feel effortless, but that is because the listening path is at play.

"I'll tell you a little trick," says veteran actress Jennifer Bassey. "I practice listening. I call three people daily and ask them how they are. I don't talk about myself. I ask them about themselves." Bassey chuckles. "Focusing on someone else keeps me from being so self-involved."

Bassey's "trick," as she calls it, enriches and deepens her spiritual life. She is a generous friend, and her generosity is appreciated. Her network of friendships is both wide and deep. Her attentive listening has earned this.

"Becoming a good listener is a learned practice," Scottie Pierce asserts. "It is not automatic. People can learn it. There's an art to good conversation. When we listen intently, we extend an invitation for others to do the same. We model good behavior. But I think there are many people who don't listen. They are so busy with themselves that instead of picking up the cues of 'your turn, my turn,' they are rehearsing what they will say next, so they aren't truly present at all."

When we practice the listening path, we do not indulge in denial. Focused on taking in another's reality, we often find our own reality coming into sharper focus. If, as Scottie Pierce says, we are talking to someone who doesn't listen, our bodies may clench in response. "They're not listening," our stomach may tell us. Conversation with them is futile. Rather than push forward, we may choose to disengage. We excuse ourselves with a graceful apology: "Got to go."

Using the tool of listening to others does not mean we stop listening to ourselves. The listening path is not masochistic; rather it is realistic, built on the accurate appraisal of where and with whom we can experience reciprocity. Listening to others, we register how able they are to engage deeply. We focus our attention on those who

Being heard is so close to being loved that for the average person, they are almost indistinguishable.

—DAVID W. AUGSBURGER

can respond to us in kind. They are our believing mirrors, and we collect them with care. Listening deeply to others, we recognize those who can listen in return. They become our sounding boards. They mirror back our potential and strength.

I recently bought a house—my first in twenty years. It felt like a big commitment, and I turned to my believing mirrors for advice. "The house is perfect for you," Scottie Pierce said. "It's safe, comfortable, and lovely." I was reassured.

"You'll love the house," said Jennifer Bassey. "It has mountain views and a garden—two things you said you missed." I was reassured.

"I think the house suits you," said Emma Lively. "It's sunny and spacious." I was reassured.

It takes two to speak the truth—one to speak and another to hear.

—HENRY DAVID
 THOREAU

Listening to the feedback of my believing mirrors, I decided to set aside my fears and buy the house. My believing mirrors had confidence in me. They thought ownership would be good for me, saying, "You deserve to own your own home. You deserve a home you love."

Buying my house, I listened not only to my believing mirrors but also to myself. My friend Gerard Hackett walked me through the purchase a step at a time. "It's a good house," he reassured me. "Ditto," said Scott Bercu, my accountant—another believing mirror. Taking in the encouragement of my believing mirrors, I was able to note that their optimism for this endeavor rang true to me. I, too, had faith in this idea. I, too, believed on the deepest level that I could and should buy the house that spoke to me. Listening to my believing mirrors helped me listen to myself.

Believing mirrors prove themselves over time. Gerard Hackett has been an invaluable friend for more than fifty years. Gerard is level-headed and calm. Presented with a dramatic situation, he listens carefully and then defangs the drama. A longtime practitioner of the listening path,

Gerard listens with care, taking in my nerves and gently dismantling my anxiety. He refuses to panic.

When I teach, I talk about believing mirrors—Gerard in particular.

"But, Julia! What if I don't have a Gerard?" I am sometimes asked.

I explain that listening carefully to our friends and acquaintances is a sorting process: some will prove themselves more sound than others. The soundest may even be a Gerard in the making.

Listening deeply to others while listening deeply to ourselves brings us to a point of balance. This point is the beginning of wisdom. With time, it becomes automatic. We learn, through practicing the listening path, that it is more satisfying and enjoyable to listen than to not. As we listen, so does our partner.

The key to a successful conversation is reciprocity. If one person dominates the discussion, the listening path is foiled. "Your turn, my turn" is the rhythm that we are after. It is a dance. A good conversation is a learning opportunity. Each person shares fully, and the witnessing partner takes in new ideas. There is a palpable current that we feel and respond to. We listen for our cues that it is our turn to talk. We don't interrupt by jumping in prematurely.

When we interrupt our conversational partner, we lose a valuable chance to learn. Uninterrupted, our partner may come forward with new and often surprising tidbits of information. "I never thought of it that way," we may catch ourselves thinking as we open our ears and our minds to novel thoughts. We do indeed learn to listen and listen to learn. Practicing patience, we invite our partner to fully explore an idea. We may catch ourselves tempted to interrupt, but knowing the value of an uninterrupted train of thought, we resist the temptation. Our partner is startled at first, then pleased, by our alert

You never really understand a person until you consider things from his point of view.

—HARPER LEE

attention. Unspooling a line of thought, our partner discovers new thoughts, and thus learning occurs for both partners.

It takes patience to fully hear out our partner. Sometimes their thoughts are complex and intricate, not easily attended to. We must muster our full, focused attention. Anything less will not do. Alert, serious, and empathetic, we signal "you matter." Deep conversation is the result—conversation that doesn't feel rushed and is mutually satisfying. Respect for our partner is the key.

◄ TRY THIS ►

For the next week, listen carefully and with full attention to conversations with your friends. You may wish to keep a log of your reactions. Some friends are better listeners than others. Record a note that tells you "good, bad, medium" about your friends' reciprocity. You are on the hunt for a believing mirror—a friend who reflects back your strength and possibility. Note who leaves you with a feeling of optimism. That person is invaluable.

LISTENING TO THOSE WHO LISTEN

When I was in my twenties, I worked for *The Washington Post,* which led me into a period of journalism—writing for the *Post* and then for *Rolling Stone.* I witnessed, and learned, that the best reporters followed the story rather than trying to control it. In other words, they listened. When a writer allowed the story to unfurl naturally rather than trying to shape it prematurely, the most interesting and most honest reporting was done. I aimed to follow this example myself, listening to the people I interviewed, staying receptive and open, and giving them the space to

share what was true to them. As I listened, they shared more. As they shared more, the shape of the story became evident to me. As I listened, the story revealed itself, and as the story revealed itself, the writing came easily.

Writing this book and thinking about listening, I am brought back to those early days. I decide I will ask my friends to speak about listening—and that I will listen.

Ironically, just as I decide to do this, my phone stops working.

"Julie, are you there? I can't hear you." Emma Lively's worried voice comes over the phone.

"Yes, I'm here," I answer.

"Julie, I can't hear you."

"Emma? EMMA?" I try talking louder.

"Julie, I still can't hear you," she insists.

"I'll try you on the cell," I say, speaking loudly and distinctly.

I hang up the phone and then dial my cell phone. "Emma?" I ask when she answers.

"Julie! That's better. Now I can hear you."

"My phone is on the fritz," I tell Emma. "My landline."

"Yes, I can't hear you, but I do hear a lot of static. I'll send you a new phone."

Two days later, the new phone arrives. A friend installs it for me. I try dialing Emma. When she answers, she announces, "I still can't hear you."

I hang up and call her on my cell phone. "Emma?"

"Now I can hear you."

"I'm back on my cell. There must be something wrong with the phone line. The phones themselves are fine, I think."

"You'd better call your phone company."

I do call, scheduling a technician for the following week—the soonest available, which doesn't seem soon enough at all.

The phone shrills again. My caller is Jennifer.

Have you ever noticed how the most intriguing individual in the room seems content to listen sooner than speak?

—RICHELLE E. GOODRICH

"I can't hear you," she complains. "Do you have a fan going?"

"No. There's something wrong with my phone line."

"What? I can't hear you."

"I'll call you on my cell."

"What? There's something wrong with your phone."

"Goodbye. I'll call you."

So I dial Jennifer's number into my cell phone. "Jennifer?"

"There. That's better. Are you sure you're not running a fan?"

"Jennifer, I told you, no fan. There's something wrong with my phone line."

"Well, you have to do something. It's like you're a half mile away and underwater."

I resolve to do my interviews in person. I will invite my friends to meet up for coffee or meals, and I will listen. I am again reminded of my reporter days, when in-person meetings were always preferable to phone. I pick up my cell phone, faith in the landline lost, and begin to set meeting times with good listeners I know: visual artists, actors, musicians, writers, teachers, filmmakers. As I reach out to my many and varied friends, I am struck by the many and varied types of listening they all practice. My friends are responsive and excited to get together and talk about listening. As I set date after date, mixing up locations and making plans with those I see often as well as those I see rarely, I again see how listening leads to connection. I look forward to seeing my friends "live," and I even see the silver lining in the phone's being out. Each interview will be an adventure. This will be fun.

SCULPTOR AS LISTENER

There is a rap at my door. It is four o'clock, the appointed time for a visit with Ezra Hubbard, artist. I open the door

and the tall, lean young man steps inside. He hugs me hello. Now in his early forties, I have known Ezra since he was sixteen, a talented teenager. Now his talent has blossomed, and he pursues an artistic career. One of his sculptures enjoys a place of honor in my living room. He paints as well as sculpts. He also creates interdisciplinary installations and clearly enjoys all modes of art. I offer him a tall glass of water, which he accepts with a twinkle.

"These glasses are beautiful," he says, sipping from a hand-painted Mexican flask. We toast to his career.

"I have an hour and a half," I tell him. "Then I'm due across town. What do you say we walk the dog?"

It's an invitation I know he will accept. We have walked dogs together since he was a teen. I was then in my forties, Ezra's age now.

"Where's Lily's leash?" Ezra asks by way of acceptance. I retrieve Lily's leash from its place on my coat-rack. Ezra snaps the leash to Lily's collar and we set out. It is a clear, cool afternoon in early fall, and Lily sets out at a trot.

"Easy does it, Ez," I admonish. He tugs gently at Lily's leash and she slows her pace to match our thoughtful steps.

"What do you think, Ez? Does listening play a part in your art?" I am eager to hear his response.

"Hell yes, listening plays a part. Listening tells me what to do next. I listen and make a piece. I listen again and make another piece."

"So listening is the through line?"

"Exactly."

We walk on slowly. Lily darts to the end of her leash, the better to sniff at the golden chamisa bushes. Ezra has news to tell me: he and his wife are selling their compound in Pecos and moving to New York, where they have spent two happy and productive summers.

"In New York, I have cohorts," Ezra explains. "We're

Part of being successful is about asking questions and listening to the answers.

—ANNE BURRELL

too isolated out here in Pecos. I have no one to share my art with."

"So you miss fellow artists?"

"I do. In New York I have an ongoing conversation that feeds my art." Ezra pauses and tugs at Lily's leash. "Let's go this way," he suggests, heading onto a dirt path. After a moment's hesitation, Lily follows.

"I think of art as a spiritual journey," Ezra continues after a beat. "They say God speaks to us through people, and New York is full of people."

"Does it follow that New York is full of God?"

Ezra laughs. "I don't know that my New York friends would see it that way, but I do," he volunteers. "I never know when I'm going to hear something."

"So you're going to New York to listen?"

"Or be listened to," he suggests. "I don't enjoy creating in a vacuum. In New York, my work is well received." We walk on in companionable silence. Then Ezra picks up the conversational thread. "You asked me about listening," he says. "My life is about listening. In the morning I write my pages and listen. Ideas flood in on me, sometimes before I'm done with my pages. I listen and plan my trajectory for the day. I listen to my thoughts and I listen to silence. Sometimes I take a walk and listen. You know, New York is a great city for walking. When I walk, I integrate my ideas."

It has been a luxury, having Ezra close at hand in Pecos. I will miss him, and I tell him that. But I think that for him, the move is a good idea. I tell him that, too. Before I lived in Santa Fe, I lived in New York for ten years and found that city good for my art.

"I'm doing it backwards," Ezra exclaims. "Most people live in New York and then move to Santa Fe. I'm doing the reverse."

"It will be good, Ez," I tell him. Our conversation has

Listening is a gift of spiritual significance that you can learn to give to others.

—H. NORMAN WRIGHT

satisfied me: that he practices the listening path, and that he is well and carefully led.

◄ **TRY THIS** ►

Enlist a friend for a long walk. Ask what plans, if any, are pending. Get current with each other.

LISTEN TO LEARN

Nick Kapustinsky looks dashing. We meet at one of our favorite haunts: the Red Enchilada, a divey New Mexican restaurant that could easily be missed by those who don't know to look for it, but is known as one of the best and most authentic plates of food in Santa Fe by those who do. The walls are decked out with primitive murals. The booths are painted bright turquoise. Clad in black from head to toe, topped off with a fire-engine-red ball cap, Nick's beard is neatly barbered, and he speaks neatly as well.

"I think I learned to listen as a child—an only child," he states. "The adults talked over my head. I wasn't allowed to interrupt." He shrugs his shoulders at the memory.

"My father was a particle physicist," he continues. "The talk was of protons and neutrons—the world as it was made up back to the Big Bang. I listened and learned. There was no breaking into the conversation. My parents talked to each other. My father was brilliant, and my mother was very smart. I was smart, too, but there was no room for me, so I learned to listen."

A listener still, Kapustinsky pauses. "Have I told you enough?" he asks. "I became a listener because there was no other recourse. My father was charismatic, and I

deferred to his brilliance. It wasn't until much later that I realized I had stories of my own."

A writer and an actor, Kapustinsky now takes his turn at center stage. But his childhood conditioning has made him the sensitive artist that he is today. As a writer, he is an observer, while as an actor he is responsive to those with whom he shares the stage. Deeply passionate, he nonetheless is generous, waiting his turn in the limelight. From his parents, he learned to bide his time, never interrupting. "Listen to learn," he was taught, and he puts this axiom into practice. A conversation with him explores the depths. Pauses punctuate the conversational flow. He waits patiently for his partner to complete a thought. There is no jumping in, no rushing ahead. He listens as he was taught to listen: respectfully. His full attention catalyzes conversations that are deep and spirited. Moving topic to topic, he is never rushed, nor does he rush others. Listening is for him a sacred trust.

"You were saying?" he may prompt, sensing a thought left unfinished by the speaker. His gentle probing encourages his partner to explore deeper waters. Listening with alert attention, he invites revelation. It is easy to picture him as a child, listening rapt to his elders. The child of a charismatic father, he is charismatic himself—speaking, when it is his turn to do so, with dignity and grace.

◄ TRY THIS ►

Make a plan to meet a friend for coffee, a meal, or a chat on an outdoor bench. Listen carefully to your friend, with the intent to learn. We can learn from everyone we listen to. When you focus on this result, what do you discover? What do you learn?

LISTENING TO THE HUMAN FACE

At home in her newly bought and painted house, portrait artist Cynthia Mulvaney sits on a leather sofa, her blue-jeaned legs curled under her. Her sweater-clad torso twists to face me. We have just finished Thanksgiving dinner, and we are talking. While her fiancé, Daniel Region, brews us a strong coffee, Cynthia volunteers, "His voice attracted me to him. He's got a strong but friendly voice. He's got a voice that invites you to talk."

Right on cue, he emerges from the kitchen with two steaming mugs of coffee. "Here you go," he says, settling the mugs on the coffee table. "Let me know if you need anything else."

"Thank you," Cynthia says. Then she turns again to the topic of listening. She has given it a lot of thought.

"As a portrait artist, I'm always trying to get the feeling of who a person is," she explains. "I listen to them talk and I register what I hear and what I see. They'll tell me something pivotal, like, 'My father was kind, and I try to be,' and I will try to bring out that quality when I paint." Cynthia crosses to a cabinet, and talks over her shoulder as she leafs through a drawer. She wants to show me what she means.

"I was the director of the arts council of Columbia County, New York," she continues. "In that capacity I met all these interesting people. Artists would drop by wanting a venue for their work, and we would talk, sometimes for hours. I got to know the people behind their art. They had all sorts of interesting lives. I got to thinking I wanted to bring their stories out—that people in the community should know how fascinating the people I met are. That was the seed of an idea. I applied for a grant and I won it. I interviewed people, wrote up their stories, painted their portrait, and asked each one to submit a photo of themselves that they liked. The project

Listening, not imitation, may be the sincerest form of flattery.

—JOYCE BROTHERS

was satisfying to me. I love the human face, and trying to capture who they are."

Cynthia leafs through a set of thirty-two images. Her portraits brought the people and their stories to vivid life. She says, "My interviews taught me the guts of who they are. Listening to them, I connected more and more closely. It wasn't just superficial. Everybody has interesting stories. People have so many things to tell you, if you talk and listen to them. I think I'm a good listener. I've known people who cut you off. That's a shame. When you listen, really listen, it shows you care. It helps and encourages people. You learn things you didn't know—fascinating things. I listened and learned. I think listening is an art, a skill that takes thought. It takes time to let information in. I consciously decided I would prefer to listen rather than talk. You're creating something beautiful when you listen to people."

◄ **TRY THIS** ►

Collect a beloved photo of a beloved. What personality traits are apparent in the shot? Is there a song that resonates with the photo? Buy a card and send it to your beloved. Write: "I heard this song and thought of you."

JOURNALIST AS LISTENER

Slender and lean, blond, curly-haired, with alert blue eyes, Peg Gill is dressed casual chic. She is a journalist, the associate magazine editor of a very successful regional lifestyle magazine, *Inside Columbia*. Founded in 2005, the magazine has thrived, introducing Columbia, Missouri, residents to one another.

Gill describes the magazine. "We do a section we call 'Encounters,' where we introduce our audience to people in the community we think are interesting, worth knowing," Gill explains. It is her job to interview people for the section, and in her job, listening is pivotal. She explains her strategy.

"I ask the interviewee what they are comfortable with—in person, by email, or by phone. Accuracy is important. Listening is key. Too many people are impatient, and they interrupt. We have a tendency to want to get our thoughts across, and we don't give people the extra beat or two to finish their thought. We, as a society, are too quick to jump in with suggestions. We may try to complete their thoughts or sentence."

Gill theorizes, "People are too busy, too high-speed. Taking time to listen takes focus, to be very present in the moment—not spinning ahead. Instead, try to get the full gist of what they are saying. You may have a list of questions, but the person may veer off script. You need to listen effectively and go with someone on a tangent. Sometime a story may take on a different route if you listen. You can plan it out, but that doesn't do justice to the subject. You have to be willing to *really* listen. There's a deeper level of listening that can come out when you're not married to your questions."

Gill explains what she has discovered. "Many people are lonely, that's the word. People like to be validated and acknowledged. They may not get that in their day-to-day work environment. They may not feel their voice is heard. It's common to feel they're not heard or listened to. An interview is validating."

She continues with a further thought. "Society has so many superficial conversations—polite and ritualized, but not anything deeper. It's a very charged time for conversation. A lot of people try to skate around, not go to a deeper level. They just make nice. In the current

There is a difference between truly listening and waiting for your turn to talk.

—RALPH WALDO
EMERSON

dynamic, people are not able to listen. They just react, because topics are so divisive. It's very hard and sad." Gill sighs, and has a concluding thought. She says, "Listening takes patience, very much so. It's too easy to want to jump in, give someone the word they are searching for or complete their thoughts, which you think you know but may not. To give someone time to complete their thought is difficult and takes patience. Patience is a huge part of listening."

◄ **TRY THIS** ►

Many people are lonely. Take the time to place a phone call to a far-flung friend. Be patient and listen to them. Ask them how they are and allow them the time and space to really answer. After the call, mail them a card. Tell them, "I really enjoyed hearing about X. Thank you for sharing that."

NOVELIST AS LISTENER

Internationally known medievalist and novelist John Bowers is a slim, dapper man with a closely trimmed beard. His eyes are lively and his face is mobile. Clad in professorial garb, he talks in distinctive sentences, exploring his topic with enthusiasm. Talking to me about listening, he waxed eloquent, speaking smoothly and with conviction.

"My work as a writer starts with my experience as a reader. I am a very slow reader. I read at the pace of a speaking voice inside my mind. In recent years, I discovered the marvel of audiobooks. Listening to them, I realized that the great writers are meant to be heard." John pauses to allow this thought to sink in.

"Jane Austen," he continues, "read aloud her novels to her family. Listening to audiobooks of Jane Austen's novels, recorded by the wonderful actress Juliet Stevenson, I can hear the wonderful flow and cadence of her sentences. I hear a wonderful flow, even in the audiobooks of *The Lord of the Rings*. Tolkien read aloud his chapters to his friends the Inklings, a literary group in Oxford. When I write," John explains, "I hear my sentences. I listen to my characters. I imagine characters who listen to each other. In my novels, one character will remind another, 'Don't you remember when you said . . .' The characters have always been listening to each other.

"I suppose they call it style," John speculates, "being constantly aware of the spoken word. Even in narrative passages, I listen for the voice of the narrator. When I create characters, I listen for their individual style and rhythm."

John continues thoughtfully. "There's a proverb: learn to listen, listen to learn. It has taken most of a lifetime to learn to become a better listener. My temptation is always to listen to a friend's first sentence and then to hijack the conversation and reply with a paragraph, not letting my friend get out with a second sentence. When I hijack the conversation, I am only saying what I already know. When I listen, I learn something that I don't already know. Learn to listen, listen to learn."

John pauses after this confession. He says of himself, "I'm not a good listener." He comments further. "I suppose the frustration for a writer is being able to script the conversation in a novel but letting other people script the conversation in real life. However much I think I know what somebody is going to say in real life, they never say what I expect. And so I need to listen."

John has a final, rueful thought. "In my writing, sometimes the most magical moment is when a character says something that even I as the author didn't expect to hear."

Emma felt that she could not now show greater kindness than in listening.

—JANE AUSTEN

My need to show what I can do is keeping me from finding out what other people can do and what we can do together.

—KATE MURPHY

⏴ **TRY THIS** ⏵

Phone a friend and ask how they are doing. Don't hijack the conversation. Instead, practice patience. Allow your friend to speak without interruption. Does what he says surprise you? Are you learning to listen and listening to learn?

LOCATION SCOUT AS LISTENER

Todd Christensen is a burly man with red-gold hair. Casually dressed, his manner is calm, yet alert. He is a movie person, a location manager and scout—and in his free moments, he is a wonderful painter. I have known Todd for three decades in five cities. I have found him to be unfailingly kind and generous. When I ask him to talk to me about listening, he readily agrees. Listening is a large part of his job, and he has given it much thought.

"Listening is extremely important," Todd begins. "I tell people what I do, and then I listen to their concerns. I listen to the director, and then I listen to the location. Both sides have concerns. My job is listening on both sides. It's a matter of matching. Finding the location is the first part; listening is the second part. I try to get as much freedom from the location as possible."

Todd pauses, wanting to be clear. After a moment, he continues, giving an example. "Recently I worked for the Coen Brothers. I found a location, and then I heard the owner's concerns. But I also heard that he wanted to do it. I told him that when we go to a location, we try to be very careful about where we are. The day we went to film, the guy was very nervous. I brought Joel Coen in to talk to him. Hearing what needs to match, I try to get both sides

Good listeners, like precious gems, are to be treasured.

—WALTER ANDERSON

together. I listen. I want all parties to be happy. Listening allows me to match solutions to possible calamities. Listening becomes my conduit to making things happen on both sides. Once they were satisfied that they were heard, we were able to go ahead."

Todd backtracks to make sure I understand. He explains, "First I talk to the production designer. He tells me what he wants. Then I talk to the producer, who wants to know 'How much will this cost?' Next we talk to the director, who agrees or disagrees with what we have to show him. Listening is a huge percentage of my job. I have to hear what every department needs, and then I have to make those needs happen. And this for twenty to forty locations."

To date, Todd has worked on thirty-four films, ranging from *The Ballad of Buster Scruggs* to *The Hunger Games* and *Moneyball*. He continues. "I take notes that come to me through listening. Once I write something down, I don't forget it. Then, in scouting, I listen to my instincts. I listen to my gut."

Still dissatisfied that he isn't clear enough, Todd goes on. "Listening creates favorable groundwork. Listening is respectful. I am careful, listening, not to interject any negatives. I may just say, 'Let me check on that.' Usually I know the answer. Let's say they want a road closed for twelve hours. I know we're likely to only get four. When I listen, I don't have to answer immediately. I hear, 'I need to work that out.'"

Todd has a final thought. He sums up his thinking in a phrase: "Listening is the glue for much of what happens after listening." He elaborates: "Directors, assistants— everybody depends on my listening carefully. My listening is important to hearing what we need to do to get the picture on the screen. When my listening isn't right, it will affect every department. Listening is the glue to put it all together."

◄ **TRY THIS** ►

Take yourself to a movie. Notice significant locales. Ask yourself, "What if the scene were set elsewhere? How important is the setting to the meaning of the scene?" For example, if the scene is set atop a skyscraper, would it have the same tension if it had been set on the ground? Imagine listening to the production designer saying, "The setting for this scene must be threatening." Imagine taking a note: "threatening." Can you fulfill his needs?

LISTENING AND AUTHENTICITY

Jennifer Bassey has a thrilling voice, low-pitched and dramatic. Slender, silver-haired, lithe, she has been a professional actress for fifty-three years, and her art has trained her to listen. "I think listening is probably the most important thing we do," Jennifer asserts. "When you're really listening, really in the moment, you're learning things—gathering information from the other person. When you listen, you might laugh, you might cry, you might hear something humorous or tragic." Jennifer pauses, gathering her thoughts.

"Listening is an art," she continues, "and it can be learned. When you're really listening, something sparks you and you're tempted to interrupt, but you must not. Instead of interrupting, let the person finish. Let them clearly state what they're saying. People love you when you listen to them."

Jennifer proves her point. "The women who have married the most powerful men in the world all have one attribute in common: they're great listeners. Elizabeth Taylor was a great listener. She would focus her great

violet eyes on the speaker, making him the most important person in the room. Noël Coward was another great listener. When you spoke, he was totally there. Coward made everyone feel important. My late husband, Luther Davis, was a great listener. Lots of writers are great listeners—they're always gathering information. Speaking personally, as an actor, if you're not really listening, you're in big trouble. Acting is listening, reacting and responding. It's like playing tennis."

Jennifer stops to marshal her thoughts. In her throaty, theatrical voice, she continues. "When you're falling in love, you're more present and listening to every word. Listening is a large part of falling in love. You want to listen to the person you're falling for. When my husband and I met, we spent hours talking about our careers and our lives. And so I fell." Jennifer laughs at the memory. She goes on: "A person's voice can make you fall in love. Think of Cyrano de Bergerac. The lady fell in love with his voice—she loved the man with the big nose who was ugly, not the blond and gorgeous man. She fell in love from listening."

An appreciative listener is always stimulating.

—AGATHA CHRISTIE

Jennifer's voice drops down a register. She grows reflective. She makes a surprising confession. "I have attention deficit disorder—ADD," she says. "I have to really focus and lock in to listen. So sometimes I'm a good listener and sometimes I'm not. With ADD your mind is on a very fast train. You have to work to slow it down enough to hear, really hear, what the other person is saying. I hope to be a good listener. I strive to be a good listener. I value people by how good a listener they are." Jennifer has a final thought, born from her experience. "If you are not present enough, you don't remember accurately. Your memory becomes flawed, not totally accurate."

"Careful listening then leads to authenticity?"

"Exactly."

> **◄ TRY THIS ►**
>
> Think back to a time when you were falling in love. Did you have great conversations with your beloved? Where were you? Sketch in the scene. Example: "We were in the Cecil Beaton suite at the St. Regis hotel. The suite had bold colors and a round window looking up Fifth Avenue. We lay together on the carpeted floor."

MUSICIAN AS LISTENER

I have worked with Emma Lively for almost twenty years. A close-bobbed platinum-blond beauty, Emma is fit, both physically and spiritually. Clad in hip black artist's garb, she looks creative, wearing a tunic and slender slacks. A longtime practitioner of the listening path, she has evolved according to its dictates. When I met her, she was just finishing a master's degree in viola performance. She has now evolved into an accomplished composer. Through the years, I have witnessed her listening skills sharpening. I ask her to talk to me about listening. Modest but a good sport, she agrees.

"Listening is very important to me," Emma begins. "I was trained as a musician, so I am wired to listen to everything and to hear everything. I think some people listen carefully, and some people don't listen-—they interrupt. I think it's good to let people finish their thoughts, listening carefully, because we usually don't know what they'll say—even if we think that we do. It can be very interesting to hear what people have to say. In fact, it's pretty much always interesting, if you let people say what they have to say." Emma pauses, gathering her thoughts. She continues. "You can develop listening like a muscle—the

habit of listening. It's a matter of turning your attention to it. I think if you really listen to people, you tend to remember what it is they had to say, and so you learn."

I ask her to talk to me about being a composer—to my eye, a specialized form of listening. "Ah, let me see," Emma starts off. "I had one teacher who said, 'Music is out there, and composers are the people who go looking for it.' When I write music, I 'listen into the void' and look for ideas. They always come if you listen for them. I look for music and try to shape it. I kind of pull it out of the air, I guess. I've written songs since I was really young—like four or five. I've always heard music. I can't imagine not hearing it. As time went on, I became more conscious, learning to listen well. So I've always been a composer—just over time, a better one." Emma stops talking. Her modesty is catching up to her. Is she bragging? she wonders. I assure her not. She begins again. "I went from playing other people's music to writing my own. It was more challenging and exciting. It seemed like a much bigger risk, and also like the thing I needed to do. I was drawn to it. The more I would write, the more I would know. To date I've written six musicals. I feel there's always a new idea—the ideas are calling to me." Emma can't be coaxed to talk further, but I try.

"Tell me about lyrics," I beg. Emma thinks aloud.

"When I write words, I think I hear a little bit ahead. It's kind of like taking dictation. Lyrics are more like math; you have to fit things into their boxes. You search around for the right word or words—usually I know what meaning I'm looking for and what kind of rhyme. It's a matter of listening to alternatives until something fits." Emma finishes with a final thought, a modest one. "I think I've learned to become a better listener. If you focus, as I have, on listening, then you do become a better listener."

Listening is a form of spiritual hospitality by which you invite strangers to become friends, to get to know their inner selves more fully, and even to dare to be silent with you.

—HENRI J. M. NOUWEN

◄ **TRY THIS** ►

Cue up a favorite piece of music. Listen to it carefully. What are your associations? Listen again—again, carefully. Are your associations the same? What do you think the composer's were?

CAN YOU HEAR ME NOW?

My phone shrills and I rush to answer it, forgetting that to my caller, my voice will be inaudible. It is Jennifer on the line, and when she cannot hear me, she grows impatient.

"When are you going to get your phone fixed? This is just terrible."

I explain to her that I have had three visits from technicians, all to no avail. She cannot hear my explanation. To her, my voice sounds garbled, as if I'm speaking underwater.

"What?" she says. "I can't hear you."

"I'll call you back on my cell phone," I say, and I do exactly that.

"There," Jennifer says, "that's better."

"I'm on my cell," I tell her. "How are you?"

But Jennifer is not to be deterred. "Why can't you get your landline fixed?" she demands to know. "It's really quite annoying."

"I agree," I tell her. "Each time a technician comes, he declares it fixed, only to have it up to the same bad behavior as soon as he leaves."

Now I am on my fourth technician. This one has a solution: "You need to get portable phones," he tells me. "Your conventional landlines draw too many volts."

I've never had a portable phone, so I am skeptical about his solution—skeptical but desperate. I drive to the Office Depot, where I purchase a new model portable phone with three extensions. A friend comes over to the house and sets them up.

I call Jennifer. "Jennifer," I ask, "can you hear me now?"

"Yes!" she says. "Have you finally fixed your problem?"

"If you can hear me, then I have," I say.

"I can hear you," Jennifer assures me. "It's about time."

It has been a strenuous period, writing this book while not having a phone. Now that my connection to others is once again clear, I realize what a source of stress it has been to not be able to hear—or be heard. Writing about listening, I am even more aware of the frustration of a poor connection, and even more grateful for a good one. "What joy listening brings," I think to myself. And then "What an apt thought to have while focusing on listening."

Hopping off the line from Jennifer, I call my friend Daniel Region. I confirm that we are meeting at noon.

LISTENING AS
SURRENDERING CONTROL

"I'm meeting a handsome man named Daniel," I tell the hostess as she ushers me to an empty booth. "He has red hair."

"I'll bring him to your table," the hostess promises. I settle down and order a tall glass of passion fruit iced tea. Daniel arrives a minute later. He is clad in denim from head to toe, sporting a pair of Tony Lama cowboy boots. His rugged good looks make him a striking Western figure.

"I'll have the same," he tells the waitress. When she returns with his tea, we're ready to order.

"Steak salad without the steak," I order. "With sweet potato fries."

"Fish tacos with sweet potato fries," Daniel orders.

We smile at each other. "The sweet potato fries are good here," I remark.

"That's what I remember," says Daniel.

"I've never had a bad meal here at the Santa Fe Bar & Grill," I tell him. "Everything is tasty."

"It's your home away from home," Daniel remarks.

"That it is," I agree. I take out a sparkling blue notebook and pen. "Shall we?" I ask. I have invited Daniel to lunch to talk to me about listening. His résumé reads *Daniel Region: actor, director, writer, photographer.* It seems that he develops a new skill every five minutes. A longtime practitioner of *The Artist's Way,* he writes Morning Pages daily, and he follows where they lead. He began his creative life as a radio announcer and voice-over talent. Then he followed the urge to act. A long and successful acting career led him to directing. In between directing jobs, he wrote short stories. In between short stories, he became a photographer, filling the need for good headshots. On any given day, he may pursue multiple talents. Today, knowing he is going to be interviewed, he put on his sonorous radio voice. So what about listening?

"Listening is the most important thing you can do," Daniel starts off. "In order to listen, you have to connect to others. Listening is crucial to connection. Lots of people only pretend to listen. They are waiting with the intent of what they will reply. This is an attempt to control. True listening means surrendering control, being present to the moment as it unfolds. Listening is a very powerful tool. In any interaction, listening is the most important thing you can do. It gets you out of yourself and teaches you to connect to what's around you."

It was an honor, to be listened to closely, to be heard. One could honor someone without agreeing with them.

—MEG WAITE CLAYTON

Daniel pauses to sip at his tea. His brow is creased in concentration. He asks me, "Does anybody listen anymore? Too often, people are listening to push their own agenda. True listening requires you to tune in, surrender your agenda, really understand what the other person is thinking, really listen to what is in their heart."

Our meals arrive. We eat for a few moments in silence. Then Daniel picks up the thread of our conversation. "Listening creates a circle. You are open and vulnerable. You are tuning into what the other person intends."

I take bite after bite of crisp salad. Daniel wolfs down the first of three fish tacos. He continues. "I learned to listen being an actor, studying with John Strasberg and Geraldine Page. From them, I learned the importance of listening. The most important thing you can do as an actor is to listen to the other actors in the scene. Too often, actors, instead of listening, are waiting for their cue line. That makes a disconnect, as they're not truly listening. When you truly listen to the other actors, you are given what you need to continue. If you listen, your line will automatically be there."

Daniel's second fish taco goes down the hatch. He licks his fingers, then elaborates. "Listening is about respect: respect for the other person speaking. Your respect for who they are opens you to what's in their hearts. You may find yourself thinking, 'I never thought of it that way.'"

Daniel stalls at the third taco. He leans forward, the better to convey his next thought. He speaks carefully. "Listening is about surrendering control," he says. "It's like falling in love—yes, it's very like falling in love."

> ◄ **TRY THIS** ►
>
> Try listening for the direction your heart is leading you. Ask your heart for guidance, and jot down the guidance you are receiving. Is it different from your head's intellectual direction? Where does it point you? Listening to our inner guidance, the voice of our heart, we are led in the "right direction."

LETTING OTHERS SPEAK

The coffeemaker is bubbling and hissing, a demonic sound. I am making a midday pot of French roast coffee. I have just worked out with my trainer, and she told me a story from a book she was listening to. The narrator was a dog, and when asked what he would do if he suddenly became human, the dog replied, "I would listen. Humans don't listen."

It's true that Lily hears visitors before I do. If someone opens the courtyard gate, Lily races to the glass-paneled sliding door and peers out. If it's someone she likes, she yips excitedly. She has a particular fondness for two of my helpers: Juanita, my housekeeper, who has three dogs of her own, and Anthony, a skilled handyman, who treasures his fourteen-year-old pit bull. When I open the door to them, Lily leaps for joy. Rather than race outside, she hovers nearby and escorts them in.

"Hello, girl, you love me, or perhaps you love my dogs," Juanita exclaims.

"Hello, baby, you love me," croons Anthony.

It's true. Lily rears on her hind legs, placing her front paws on his thighs. She woofs eagerly. The only time she displays such excitement with me is when I feed her a slice of gravlax. "Lily, salmon, treat," I chant, and that causes happiness. This afternoon Lily is ecstatic. Her

beloved Anthony is here. He is weatherproofing the garage, which has sprung a leak, and he works carefully and diligently to stop it.

"If it doesn't rain tomorrow, I'll bring a garden hose the next day and wet the roof to test it," Anthony explains. He is a meticulous worker, taking pride in doing his jobs perfectly. Today he has arrived with his wife, Carmella, a raven-haired beauty. He is working Sunday, on his day off, and she has come along to keep him company. They work together, an efficient and joyful team, for three and a half hours. Coffee brewed, I offer them each a cup. Carmella accepts, pausing at the kitchen sink to rinse off any lingering grime.

Seated in my dining room, she admires my crystal chandelier. "It's so pretty," she exclaims. Sipping at her coffee, she asks what I am writing now.

"A book on listening," I tell her.

"Listening is so important," she exclaims. She elaborates. "For ten years now, I have worked at a high-end jewelry shop. We mainly sell diamonds. I have learned that women usually know just what they want. If you listen, they will tell you in detail. I have learned to let them speak. There's no point in showing them the turquoise if a diamond is what they're after." Carmella smiles. A beautiful woman, she is; even more beautiful when she smiles.

The art of conversation lies in listening.

—MALCOLM FORBES

She continues. "We have a hard time keeping anything in stock that's over five carats. One customer has eight carats in each ear. I think that's a bit much, don't you?" Carmella smiles in quiet amusement and sips delicately at her coffee. The door to the garage opens, and Anthony joins us. Lily tries to leap onto his lap. He picks her up.

"That's my baby," Anthony croons. "You want up here with the grown-ups." Lily snuggles against his chest. He is a lovely and loving man. She soaks up his energy, wriggling with joy when he strokes her ears. We sit for a few

moments in companionable silence. Anthony finishes his cup of coffee and sets the mug in the kitchen sink. He's eager to get back to work.

When he leaves, Carmella says fondly, "We've been together forty years. And we've never had a honeymoon. I don't mind, but he'd have to take time off. And he loves working. Right now he's working on all of our children's houses—a little here, a little there."

Clearly Anthony takes pride in his work, and Carmella takes pride in Anthony.

◀ TRY THIS ▶

Ask a friend what they most want and then let them speak. Do you notice that you make assumptions about what they will want? Do you think you know what they will say—and are you surprised by what they do share? Listening to our friend's innermost desires allows us to connect to them with an often-surprising level of intimacy.

ACTOR AS LISTENER

With my phone finally fixed, I can pick it up to reach out to my more far-flung friends. I start by calling New York City, where veteran actor James Dybas has had a long and illustrious career. He began his career as a dancer, and decades later, he is still agile—a slender, handsome man with high cheekbones, lively eyes, and a ready smile. His voice is as striking as his looks. It might be described as a tender rumble.

"James here," he answers the telephone. His voice is warm, mellow, and nourishing. No surprise that in addition to acting, he does the occasional voice-over work.

He uses his magical voice to read at VISIONS—a venue for the blind—most recently reading Truman Capote's "A Christmas Memory." He enjoys being of service with his voice. When I ask him to talk to me about listening, he is modest. "Well," he says, after a thoughtful pause, "I could talk to you about listening as an actor." And so he does.

"Listening is paramount," he starts off. "There's a difference between listening and hearing. Sometimes you have to tune out what's all around you. You have to zero in to really listen. You must give attention to what a person is sending and respond appropriately."

Dybas pauses, marshaling his thoughts. "As an actor," he continues, "I studied with Uta Hagen and Mary Tarcai. They both really talked about being in the present moment, listening to who you're with. It's like a volleyball game, they said. Uta Hagen wrote a book, *Respect for Acting*. In it, she said: 'Words are sent actively, with intent. You must listen for the intent of the words in order to receive them, giving the words meaning, not only for their intention, but from your own point of view and expectation.'"

"In other words, listening is an active art?"

"Yes, precisely. In real life, we're lucky to get three-fourths of what someone is saying. We listen with our ears and with our eyes as we interpret their body language. When we are with close friends, listening, we physicalize what we're hearing—with the shrug of a shoulder, or we lean in closer. Listening physically affects us."

James cites an example: "I went to see a play called *The Gin Game*, starring Hume Cronyn and Jessica Tandy. At one point, Tandy says something that embarrasses Cronyn. His face flushed bright red—that's how well he was listening."

This memory brings him to another thought, a cautionary note: "Listening is paramount. It is of the upmost

importance. We can misinterpret email—it's tricky. When we speak and listen, we pick up cues from the way they physicalize, or their tone of voice. When a thought is written down, it's not the same. We're vulnerable to misinterpretation. Speaking, listening, you're receiving vibes from the person you are listening to—and I can tell if someone's listening to me. Their eyes blink intermittently. If they're not listening, they stare. In conversation, the tone of voice is important. Is it inviting—or 'blah-blah-blah'? Sometimes I don't want to listen."

If speaking is silver, then listening is gold.

—TURKISH PROVERB

But there is a form of listening that James does daily, whether he wants to or not. He explains, "Prayer and meditation begin my day. I pray, and then I sit silent and listen to the still small voice. It's like talking on the phone—to God. I believe that prayer without mediation is like hanging up on God before God can speak. I listen to the silence for twenty minutes. I hear a still small voice within. Sometimes it's not that still. This starts my day off feeling present and ready to go out into the world. The sounds of the city can be overwhelming—the time in silence is necessary."

◄ TRY THIS ►

Engage a close friend in conversation. Use James's trick of blinking eyes to tell you whether your friend is fully engaged in your talk. Notice your friend's body language for clues of what is important to him. Notice your own body language to gauge whether you yourself are fully engaged. Take to heart James's statement that "we listen with our eyes."

LISTENER AS CONVERSATIONALIST

Gerard Hackett and I have been friends for fifty-two years. We met as college freshmen, at eighteen years old. We connected then, and we have stayed connected. Gerard is a tall, thin, dapper man with a mustache and sparkling brown eyes. A determined optimist, he is quick to smile and to laugh. During our five-plus decades, we have had many heartfelt and meaningful conversations. I have found Gerard to be both a spirited conversationalist and a good listener, ever ready to exchange ideas. I ask him to talk to me about the importance of listening, a key factor in our friendship. He is happy to oblige.

"If you want to have a meaningful conversation, listening is extremely important," he begins. "It is a strong part of your conversational tool kit—crucial, if both parties are to be satisfied with the conversation."

Gerard pauses, then continues thoughtfully. "A good conversation is a learning experience on both sides. If each person is given the chance to speak and to listen, it is catalytic. In dialogue, learning occurs. Each one says to himself, 'That's something I never thought of myself.' Listening leads to insights. If one party is talking all the time, that's not gaining insight."

Gerard pauses yet again. He continues after a beat, waxing nostalgic. "I was brought up to be a good conversationalist, being advised as a kid to make person-to-person conversation involving active listening and active speaking. Kids watch and listen. That's what I saw modeled by conversation at the dining room table."

Back in the present, Gerard continues, "If someone does all the talking, not listening, my mind goes on automatic pilot. If you don't have two active listeners and two active speakers, there is no potential for meaningful

Most people do not listen with the intent to understand; they listen with the intent to reply.

—STEPHEN R. COVEY

conversation. When I find myself on the receiving end of a monologue, I detach myself from the conversation as quickly as humanly possible."

Gerard pauses, then goes on. "I find myself frustrated in conversations where there is not good listening, where dialogue is transformed to monologue. I don't seek out further conversation if I see a pattern.

"Listening makes you a better conversationalist," Gerard continues. "I look forward to conversations with people who are good listeners as well as with people who are articulate speakers. Those are the conversations I remember. These are conversations that are dialogues, not monologues. Each side contributes and also welcomes the other person's opinion. It's a question of respect, to listen to the person you're having a conversation with. We respect each other as people, and to not carve out space for the other person is not being very polite."

Gerard sums up his position. "You could say I believe in the golden rule: a conversational version of 'treat people as you like to be treated.' From a good conversation, you learn something new. You are denied this possibility if you are talking too much and not listening. You miss out on a lot if you're not a good listener."

◄ TRY THIS ►

We learn through listening. Take the time to consciously listen to a friend. Do not interrupt. Allow your friend the dignity of hearing a fully fleshed-out idea. Allow yourself to be surprised. Buy a postcard and inscribe it: "Thank you for a wonderful conversation." Post the card to your friend.

TEACHER AS LISTENER

Outside my living room window, the piñon tree is still, etched against the sky. It's twilight, and its dark branches are inky black. At its base, Lily stands out, snow white against the darkening sky. With the wind gone, she ventures out. The piñon tree is no longer threatening. Songbirds are tucked in its upper reaches. They are done with singing for the day and will start up again with the dawn.

Writing this book on listening, I find myself tuned into the subtle sounds of my environment. The songbirds sound loud. The wind sounded louder. This evening, the house is quiet except for the steady ticking of my kitchen clock.

Now what? Lily is barking. A harsh, sharp, repetitive bark. I worry that she will annoy the neighbors. And so, I rap on the window and carol, "Lily! Salmon! Treat!" She ignores my coaxing, and I give up. I surrender to the din. Evidently, surrender is what's called for. Lily stops barking and comes inside for her promised treat. I peel her off a slice of gravlax, and then I block the dog door. Frustrated, Lily perches on the back of the loveseat and lets out a series of woofs. She would much prefer being back outside barking loudly, but I tell her, "Hush, Lily," and hush she does. The house is quiet again, save for the kitchen's ticking clock.

Newly back from a teaching trip, I find my house lonely. I call my friend Laura to keep me company long distance. She lives in Chicago, where I used to live.

"Hello!" Laura's voice holds a welcoming lilt. "How are you?" she wants to know. "Are you back?" Knowing it is meaningless to lie, I answer, "I'm back. I'm medium."

"Just medium?" Laura asks. "What would it take to feel better?"

"Talking to you helps," I reply. "Talking to you always helps."

If we can share our story with someone who responds with empathy and understanding, shame can't survive.

—BRENÉ BROWN

It's true. Laura is always a welcoming presence. Her voice, across the line, is gentle—as lovely as she is herself. A tall, lissome blonde, she is ever gracious. Now she thanks me for my comment.

"Why, thank you." Laura's voice holds a smile.

"I think it's because you listen—really listen," I tell her.

"We've been friends a quarter century," Laura responds. "When you're friends a long time, you learn to listen beneath the words. You hear nuances from the tone of voice, the mood, how you're really feeling. I can hear beneath the words. That's what you mean by 'really listening.'"

"You're comforting. Maybe all those years of teaching."

"Thirty-five years," Laura responds. "Listening was hugely important, because that was the best way of knowing what was going on with students. Listening enabled me to know where they were at. I tuned into their tone of voice. Were they up, tired, troubled? Was there drama at home, a new sibling, perhaps? Listening, I would hear the details." Laura pauses and sighs softly. She misses her teaching days. She continues: "Listening to their questions was really important. I would have a lesson's trajectory in mind, but their questions would take me to different branches. Their curiosity took us to a tributary near the main lesson, but of special interest to them. I would follow their cues and clues—the words, the tone, their facial expressions. I listened with my full attention. I felt it was cheating to tune out, and so I listened fully."

"Which was always formidable."

Laura sighs deeply, then responds. "Maybe. If there was a conflict, I would listen to get to the heart of the matter. Listening to their stories, I got to know them little by little—and knowing them closely, I loved them more and more. I wouldn't feel right about halfhearted listening. They had my full attention."

"That's how I feel when you listen to me," I exclaim.

"Well," Laura says modestly, "I probably got better. But I never was a big talker. I was always more an observer or a listener. Yes, I was always a listener. But listening takes patience. You focus on the other person, then bring yourself forward in response. Sometimes it takes considerable patience. A person's story may be long, complicated, and full of detail. I taught gifted kindergarten up to learning-disabled thirteen-year-olds. I was always learning. I got to know my students by listening to them. Each student was unique—their interests, what they were excited about."

"I'm excited listening to you talk about work. You have such passion," I tell her.

"Passion is easy to come by," Laura says. "All it takes is focus. Focus is the key to listening."

◄ TRY THIS ►

Listen carefully to a friend. Identify their passion and compliment them upon it.

LISTENING AS AN ACT OF LOVE

A half-moon shines in the nighttime sky. It lights the mountains in Santa Fe, and it lights the mountains near Asheville, North Carolina. I am in Santa Fe, and my friend, the poet James Navé, is in Asheville. He answers his phone on the first ring. His voice is warm and welcoming, with just a hint of a southern drawl. Muscular, with a shaved head, he is an inveterate hiker, and stamina fuels his conversations.

"Navé here."

Listening is an attitude of the heart, a genuine desire to be with another which both attracts and heals.

—J. ISHAM

"I'm calling to talk to you about listening," I tell him. "I'm writing a book."

"There's a lot to be said about that," Navé concurs. "I'd say that listening is the first, the very top of the list, of skills to be cultivated."

"Go on," I urge him.

"When one listens to others," he continues, "the act of listening generates empathy. Your curiosity level rises. When empathy and curiosity mingle, there is a level of respect. In this culture, we hear noise but don't do too much listening. When you listen deeply to someone, you encounter their soul. Words are like breadcrumbs, leading us into the forest where the authentic self is found."

Navé pauses, listening to the silence between us. After a beat, he goes on. "People are hungry to be noticed, hungry to be cared about, hungry to be recognized. Listening— true listening—does all that. When you care, people sense that you are hungry to listen, and they feel a sense of home. Home feels generous. Home is where you are listened to."

He pauses again. "Listening is an act of love. Giving time is an act of deep caring. Giving time means pausing, and allowing the silence to hold emerging thoughts." Navé himself pauses, then goes on. "The core of listening is generosity, empathy, graciousness, and patience. Listening delivers a message of respect to those around you, but equally important is listening to yourself. At root, listening is an act of falling in love—with ourselves, with the people we are listening to." Navé pauses yet again. "I've given a lot of thought to listening. I have a talk radio show, and to date I've done 130 interviews. My radio show is called 'Twice 5 Miles,' after the Coleridge poem. It's subtitled 'Fertile ground for conversations worth having.'"

"You've just demonstrated that," I told Navé.

◄ TRY THIS ►

Talk to a friend one-on-one. Be alert for their enthu-
siasm. When you discover it, ask further questions
to draw them out.

THE DAILINESS OF LISTENING

It is a bright and chill winter's day. Lily is eager to get out
for a walk, so I bundle myself into my thick winter coat
and snap the leash to her collar. We set out north, up an
incline on a dirt road. The road dead-ends onto a paved
road a quarter-mile up. As we climb, a raven accompanies
us, cawing from perch after perch, on telephone poles
and treetops.

"Hurry up," the caw demands, and Lily is ready to
comply. She tugs at her leash, urging me to keep pace with
the raucous bird. I stubbornly slow down to a near stand-
still. The bird flaps into the air, doubling back until it is di-
rectly overhead, perching on a phone pole, cawing. Lily is
annoyed: she hears the bird but doesn't see it. Its caw seems
to mock her. She stops stock-still, legs braced, looking.

"It's okay, Lily," I tell her, but she is not convinced.
She gives a petulant woof. The bird caws in response. The
caw puts Lily back in motion. She leaps up as if she, too,
can fly.

"It's okay, Lily," I repeat, but the bird likes the game of
Tease the Dog. It caws even louder. Lily barks. Her bark
translates: "Come on down and I'll eat you." Perhaps
finally threatened, the raven takes to the air, this time
flapping out of earshot. I head toward home, appreciat-
ing the excitement of what could easily be missed—the
simple magic of a raven in the mountains; Lily's focus

and excitement in the face of nature. I resolve to reach out to a friend and just listen—no agenda, no interview, nothing but interest in the dailiness of another's life.

Back at home, I place a call to Jennifer Bassey. She had a day of auditions and I am wondering how they went. At seventy-nine, Jennifer has the energy of a woman far younger. Far from retired, she works steadily, winning an Emmy for her work. She is always eager to hear how my own work is going. Work is for her a central through line.

"Hello, sweetheart," she greets me. "How is it going?" She means, did I write today?

I tell her, "Fine. I wrote a bit." And she wonders if I used the twenty-minute trick—setting the timer for twenty minutes, promising myself that is all I have to do. It always makes it easier to get started—"just" twenty minutes—and started, I find I often want to continue.

"Yes!" I tell her. "The trick works." She asks me how my little dog is. Jennifer is an animal lover. Next, she asks after my daughter, then my granddaughter. The report on everyone is fine, so I finally slip in my question regarding her audition.

"I think I nailed it," she reports gleefully. "My manager loved it, so now we'll see." A veteran actress, Jennifer settles in to wait. She knows that good work is no guarantee that she will be cast. "They went with someone who looks older," she frequently reports. Her calendar age is late seventies, but her camera age is early sixties. She looks too youthful for many parts. No grandma, she. I wait for Jennifer to elaborate on "nailed it," but she is in listening mode, not speaking.

"How's your play?" she asks. "Are you ready for your January reading?"

"Not quite yet," I tell her. "I have to write two new scenes. One at the top of act one, and one at the top of act two. We need time passage."

The art of conversation is the art of hearing as well as of being heard.

—WILLIAM HAZLITT

"But I thought you had time passage," Jennifer protests. Her vote of confidence flies in the face of director Nick Demos's marching orders.

"Ah, well." She sighs, resigned that there will be changes.

"How's your husband?" I ask, knowing that he is suffering from a head cold.

"I made him my chicken soup," Jennifer replies. "He's on the mend."

Jennifer is an accomplished cook, and I can almost taste her hearty soup long distance.

"I'll have to give you the recipe," she tells me. In the past, I've had many a successful dinner party featuring Jennifer's baked salmon with mustard and dill. It's almost worth catching a cold to try out her curative soup.

"I've gotta fly," Jennifer says now. "George needs some more soup. My neighbors came over and had a few bowls full. They loved it. You'd love it, too."

I didn't doubt her. Cheered by her day's report, I said goodbye.

◄ **TRY THIS** ►

Sometimes our intimates are listened to the least carefully of all. We know them so well, we feel we know what they have to say. We interrupt them, finishing their sentences for them, but not always accurately. We don't really know their unspoken thoughts. Proof of this comes to us as we practice intimate listening. We are often surprised by what is said, felt, and thought. Select an intimate to listen to. Allow yourself patience to hear them out. Are you startled by some of what they say? Jot yourself a note: "I didn't realize that."

WHEN LISTENING TELLS US NOT TO

"But, Julia, I don't want to listen to just anyone! To be on the listening path, do I have to listen to everybody—even people who doesn't deserve to be listened to?"

I am often met with resistance—which I would define as misunderstanding—when I first describe the listening path. It can be misinterpreted by people who hear me saying, "Only listen, never be discerning." But the listening path makes us *more* discerning. It is by tuning in—really listening—that we gain the clarity to know what we should not only tune out, but what we should steer clear of altogether. The listening path is also about listening to ourselves—and trusting our impulses about who we, in fact, *shouldn't* listen to.

The little dog is eating. Her dry food crunches. Her tags jangle against the side of the bowl. Above her head, the kitchen clock tick-tick-ticks. When she pauses, the ticking seems louder. It is a gray day. A light storm passed through, but now the sky is overcast and not raining. The ticking clock marks time until I drive out for a solo dinner—a conscious choice, after a harrowing dinner the night before.

The sun breaks through the clouds. The sunset proves glorious—streaks of pink, purple, and orange. I take myself to Love Yourself Café, where my dinner is a skillet full of vegetables. Vegan heaven: kale, mushrooms, squash, zucchini, onions, sweet potatoes—topped with vegan cheese and green chili. As I dig in, I find myself replaying comments from my friends at last night's meal. Well-meaning, perhaps, but intrusive. Did I ask them?

"I don't think a little salmon could hurt."

"Eat only blueberries and raspberries—no other fruits."

"Eat lowfat yogurt instead of oatmeal."

The comments were unsolicited and unwelcome. Lately I have found myself feeling bludgeoned. I have

been on the receiving end of several monologues and I have discovered that when I am lectured to, my hearing goes. Far from practicing the listening path, I find myself tuning out. My stomach clenches and my chest goes tight. I want to say, "Who asked you?"

Nothing kills conversation more quickly than unsolicited advice. Arrogance is implied in unasked-for guidance. "I know better than you how to live your life" is the message conveyed. No wonder we resent it. The listening path is built on courtesy, not arrogance. Unasked-for advice shuts the listener down. It is a form of bullying.

"I'm only trying to help" is the most common defense offered. But the "help" sends a message that is not true help. It states—although not in so many words—"You are not competent to figure out this problem." In other words, it undermines, not supports, the listener. It triggers self-doubt, not self-confidence. It triggers resentment, which in time becomes rage.

"But I mean well" is another defense. And well-meaning friends are often blind to the hubris of their advice. Let us say they just got a good haircut. They may forcefully urge a good haircut on one who is happily growing long hair. It seems innocent enough, but is it? Isn't it really another way of saying "my way or the highway"? It's one thing to share, "I just got a good haircut," and another to say, "You should get a good haircut." Sharing personal experience differs in tone from free advice.

We all have differing needs, and differing strategies on how to meet those needs. I work at home alone, and I take myself out to dinner nightly. I am fulfilling my need for a good meal and my need for human companionship. The friend who advises me, "You should eat at home; you'd save a lot of money," is giving well-intentioned but inaccurate advice. She is married, and her home-cooked meals are shared.

"You know what you need to do," many an unwarranted

You cannot truly listen to anyone and do anything else at the same time.

—M. SCOTT PECK

piece of advice begins. It can be cut short by saying, "Yes, I do know what I need to do."

Your friends who persist in giving unasked-for advice may need to be told, "When you try to fix me, you are implying that I am broken."

"No," they may protest, "I didn't mean to imply that at all." Often they are genuinely shocked at your perspective. After all, as they put it so often, they are "only trying to help."

Although they seldom recognize it, their help is really an ego-feeding proposition. Who doesn't like to feel just a little smarter, just a little more competent than someone else? And what could be more humble than helping?

The listening path requires that we listen to others without trying to fix them, and that we speak up for ourselves when someone speaks down to us.

◄ TRY THIS ►

Make a list of those friends who you feel really listen to you, seeing you for your biggest and truest potential. These friends instill a sense of optimism and possibility, and the exchange leaves you feeling hopeful and lighthearted.

Now make a list of those friends who feel the opposite to you. Do they give you unsolicited advice? Do you feel like they aren't listening when you speak? When you listen to them, do you feel a sense of compression? Do you feel yourself resisting what they have to say in an attempt at self-protection? Of these friends, are there some whom you'd like to talk to about your interactions? Are there others you feel might be wise to avoid if possible? Simply muse on the page. When you are done, take a brief solo walk, and stay open to ahas that will bubble to the surface. What feels like the right action—or

non-action—in each instance? You may enlist your
best listeners to share your thoughts and concerns
with, and seek advice from, those who will truly
listen to you without trying to "fix" or advise you
inappropriately.

TAKING OUR OWN ADVICE

It is a chill winter day, and it is snowing. The mountains
are white; their peaks are lost in silver clouds. My house,
lower, mixes snow with sleet. There is a steady tick-tick-
tick as the elements come up against the windows. The
sound of the weather causes me to be alert. I have to drive
out later, and I dread the driving conditions. I am headed
south for half an hour on treacherous roads. I will be vis-
iting Dr. Arnold Jones and his wife, Dusty. We have been
friends for thirty years.

The tick-tick-tick stops. A ray of sunlight illuminates
the mountain. The snow and sleet are at a halt. I hear a
truck rumbling past on my dirt road. Lily flops open her
dog door and ventures out. The phone shrills. It is my
friend Taylor, calling "just to tag base."

"How was your day?" she wants to know.

"I was weather-bound until a few minutes ago—snow
and sleet, no visibility."

"And now it's better?"

"Yes, much. I hope it stays clear. I am driving down to
Arnold and Dusty's."

"You hate that drive in good weather," Taylor exclaims.
She has a keen memory, and she recalls my driving com-
plaints of treacherous roads. Now she is full of advice. "If
the weather turns sour, stay home."

"I will," I say, knowing I won't. It's been too long since

I have seen Dusty and Arnold, and they live to the south, away from the mountains, away from the snow. All winter, when I checked in with them, I was told "very little snow" when my own house was buried. I am determined today to make the drive, however tricky.

"Just be safe," Taylor continues her advice. "I think you should stay home, actually. Don't go out tonight." I have learned that Taylor has advice for nearly every situation. I have also learned that I don't usually like to take it. Even if it is "correct," the way in which it is delivered leaves a sour taste in my mouth.

"I'm having a hard time writing," I tell her, changing the subject.

"Take your own advice," she advises. "Just begin."

"Yes, that works," I allow. I find myself resenting her schooling me with my own teaching.

"Of course it does," Taylor snaps. "If the weather turns bad again, do you have food?"

"Some."

"Some? What does that mean?"

"Enough."

"Enough? What does that mean? You should keep your freezer stocked."

"I have vegetables and frozen fruit," I ante up. Against my will, I am being drawn into conversation.

"You need protein. Do you have any gravlax?"

"I do, but it's for Lily."

"She'll share."

"I'm vegan, remember?"

"I do remember, but I don't think a little salmon could hurt."

"*Mmm.*" I know better than to argue with Taylor. We get off the phone with the weather holding clear, and Taylor satisfied that I will take her advice. I, on the other hand, know I will not.

"Lily! Salmon! Treat?" I offer, and she scampers to the

refrigerator. I don't ask her to share. I take to the page. Taylor may mean well, but her forceful advice leaves me feeling bludgeoned rather than inspired. I write, searching for what I think I should do—not what Taylor thinks. Quickly, clarity comes. I know what I need to do.

Driving down the mountain to ever-lessening snow, I take the twisting roads to Arnold and Dusty's. As I thought, the roads are bare of snow. Visibility is good, and I navigate the many turns with relative ease. Pulling into their driveway, I hear the welcoming racket of their two dogs. Arnold opens the door.

"Good to see you," he says.

"Good to be seen," I reply, grateful that I took my own advice.

◄ **TRY THIS** ►

Take pen in hand. Name a situation in your life where, despite your friends' most insistent urgings, you know what you need to do—and you need to take your own advice, not theirs. Are you afraid to take your own advice, afraid to say no to your friend? Remembering that when we do what is right for ourselves, we also do what is right for others—whether it seems that way in the moment or not. Allow yourself the courage and the dignity to do as you see fit.

Check back in with yourself. How does it feel, having taken your own advice? Do you feel a sense of relief, empowerment, optimism?

CHECK IN

Have you kept up with your Morning Pages, Artist Dates, and Walks?

What have you discovered in consciously listening to the people around you?

Do you find that you feel more connected to those you interact with?

Was there someone you found you need to consciously stop listening to?

Name one memorable experience of listening. What was the aha that came from it for you?

LISTENING
TO OUR
HIGHER SELF

—⟨⟨⟨—

I tried to discover, in the rumor of forests and waves, words that other men could not hear, and I pricked up my ears to listen to the revelation of their harmony.

—GUSTAVE FLAUBERT

We have consciously listened to our environment, and we have added to that consciously listening to those around us. This week we will add another level of listening: listening to our higher selves. We have all had the experience of knowing something was right for us—or knowing that it was not. The tools of this week will help us learn to tune into that greater, knowing part of ourselves, and to access it whenever we need to—for decisions big or small.

THE STILL SMALL VOICE

The next steps on the listening path involve listening to our own higher guidance. Pen in hand, we query the universe: "What shall I do about X?" We pose our question and then we listen for a response. When I teach, I call this tool Obi-Wan Kenobi. We are inviting the guidance of an older and wiser self. The guidance we receive may surprise us. It may be simpler and more direct than our normal thinking.

Listen carefully. The answers to our deepest questions are often whispered.

—WAYNE GERARD
TROTMAN

Many of us are accustomed to seeking guidance from others. We trust others to be more objective than ourselves. We seldom seek our own counsel. We do not realize that we ourselves may be wise, so we have trouble trusting the guidance that comes to us from within. It takes practice to seek and hear our own highest wisdom.

Prayer helps us to be certain of our path. "Please guard and guide me," we may ask, listening for the guidance that comes to us. "Please give us knowledge of your will for us and the power to carry it out," we pray further,

trusting that our guidance marries our will to the creator's. As theologian Ernest Holmes assures us, we are part of God, and God is part of us. When we seek our own counsel, we are seeking God's as well. Our inner resource is the divine spark within each of us.

As we ask to be led, we are led. No prayer goes unanswered, although the answer may be subtle and require our alert attention. The still small voice comes to each of us, although it is only sometimes still and small; sometimes it is more pronounced. As we practice hearing it, we become more and more able to hear. As we ask for guidance, we are guided.

I pose my questions as L.J.— my shorthand for Little Julie. I ask,

LJ: What should I do about _____?

Having posed my question, I listen. It is my experience that the universe responds, and I jot down its guidance. I find great peace when I use this tool. One of the first times I tried it, it resulted in a powerful and lasting insight. It went something like this:

LJ: What should I do to stop being haunted by still loving my first husband?
A: Just love him.
LJ: That seems so simple. Is that all?
A: Love is simple.
LJ: I feel foolish, loving him after all these years.
A: Love is eternal, not foolish. Try acceptance.

Guided by the simple dictums "Just love him" and "Try acceptance," I felt my heart responding to their wisdom. Rather than fighting my feelings, I accepted them. I did love and would continue to love. The inner battle was over, much more quickly than I could have ever imagined. I had

suffered and scrambled, trying to understand my emotions, but when I asked my higher self the question, I realized that some part of me already knew the answer.

When buying my new house, I listened not only to my believing mirrors but also to my higher self.

"What about the house?' I queried. The answer came back: "The house is yours."

I questioned again:

LJ: But can I afford it?

"The house is yours," I heard again. I double-checked with my accountant, Scott Bercu, another believing mirror. He answered as the universe had answered: "You can afford it. The house is yours." And so, guided by inner and outer guidance, I bought the house. Obi-Wan Kenobi approved.

Some people prefer to think of Glinda the Good Witch. Gender is not the point; the point is wisdom. We are wise. Sometimes we have trouble believing that, but working with Morning Pages, Artist Dates, and Walks, we come to have a more grounded sense of our own wisdom. Listening to both our believing mirrors and ourselves, we are ready to listen to our "inner elder," to trust that a knowing voice will speak to us when we ask.

If Morning Pages lay out our track for the day, an evening check-in tells us how we have done. It can be as simple as writing

"LJ: How am I doing?"

Many times, the guidance we hear back is calm and reassuring. "You're doing well. Do not second-guess yourself. You are on track." The listening path asks us to pay heed to praise as well as pitfalls. We are striving to build a positive and accurate sense of self. As we come to trust our own guidance, we feel a calm center where once we had only anxiety.

Let yourself be silently drawn by the strange pull of what you really love. It will not lead you astray.

—RUMI

It is not vanity to believe we are guided. We are guided as we are willing to be guided. A habit of self-trust is the result of our listening and our obedience to what we hear.

Many times we are guided to take actions that seem gentle. Other times we are guided to take no action at all. I have a set of questions that I use as a spot-check inventory. The questions are simple, but the answers they provide are often profound. Facing any troubling situation, ask yourself:

1. What do I need to know?
2. What do I need to accept?
3. What do I need to try?
4. What do I need to grieve?
5. What do I need to celebrate?

The answers to these questions give us a grounded sense of who and what we are. They offer us objectivity, mincing no words. Their tone is factual, even flat. Using the questions to double-check myself, I queried how I was doing on writing this book. The answers were encouraging.

Every time you don't follow your inner guidance, you feel a loss of energy, loss of power, a sense of spiritual sadness.

—SHAKTI GAWAIN

1. What do I need to know? A: You're doing well.
2. What do I need to accept? A: You have wisdom to share.
3. What do I need to try? A: Try writing your first thoughts.
4. What do I need to grieve? A: Time wasted second-guessing yourself.
5. What do I need to celebrate? A: You've done six chapters.

Clearly I was being guided to trust myself. I was being told I was wiser than I feared. The further advice was not to waste time second-guessing myself and to celebrate what was done so far. In other words, I was being advised to think of my writing life as a glass half full, not half empty. I was to trust myself.

"But, Julia, how do you know it's not just your imagination speaking?," I have been asked.

"Now is the time to have faith," I answer, "and if it *is* just my imagination speaking, it is speaking in a far more positive tone than usual. Try taking its advice and see if that doesn't lead you forward."

In other words, choose faith over fear—for many of us, a novel idea. We are accustomed to listening to what might be called our inner critic, who is always ready with a negative. My inner critic is called Nigel. I have lived with Nigel for fifty-plus years. I picture him as a gay British interior decorator with impossibly high standards. Nothing I write is ever good enough to suit Nigel. He always has some damning criticism. Over the years, I have learned to discount Nigel. I am used to his piping up loudly whenever my work is original or brave. All of us have our own Nigel, the critic who urges us to stop in our tracks, frozen by fear.

Naming your critic, making it a cartoon character, greatly diminishes its power. It helps to remember that when you are at your best, your Nigel will do his worst. Let us say you have an original sentence—a zebra of a sentence. Instead of saying appreciatively, "Wow! Stripes! How dashing!," your Nigel will say "Stripes are ridiculous. Whoever heard of stripes?" If you listen to Nigel, you strip off the stripes. If you discount Nigel, you may have a whole herd of zebras all gaily striped. Try trusting yourself. The zebra that is "just your imagination" deserves to stay and is quite marvelous. Pen in hand, you can hear the positive, but still, the listening path requires faith. Faith leads us forward. Faith bolsters our shaky self-confidence. If the positive you hear is "just your imagination," more power to it.

Look at the world around you. Take trees, for example. There is the mighty oak, the lissome willow, the magical blue spruce . . . clearly, the Great Creator has a marvelous imagination. There is the maple tree, the cherry tree, the piñon. Trees come in every shape and size. And consider

Have the courage to follow your heart and intuition. They somehow already know what you truly want to become. Everything else is secondary.

—STEVE JOBS

the tiny acorn that becomes an oak. The creator's imagination is up to mischief. Praying prayers of gratitude for the towering redwood, your awe salutes the creator's invention. Take just a smidgen of grace and allow your own creativity to take wing. Your imagination is clearly a portal to the divine. Alert, we encounter the creator's creativity. My garden features cacti and lilies. Three birch trees anchor the northwest corner. A Japanese maple holds sway over the lavender bushes to the south. Roses bloom on the eastern border. Lilies are tucked beneath their blooms. Sitting out in a wicker chair, I marvel at the garden's diversity. "Thank you," I breathe, grateful for the beauty all around me. Songbirds carol back to me. Lily scampers across the courtyard, jumping up to explore the garden. A tall adobe wall separates my land from my neighbor's. Lily goes to the wall and lets out a woof. From the other side of the wall, Otis answers her. I hear their conversation unfurling in woofs and yelps.

"Lily," I call, "time to go in." I offer her a bribe. "Salmon, Lily?" She races to my side, jumping with glee. "Salmon," I croon, and I open the door, coaxing her toward the kitchen. She eddies around my legs as I open the refrigerator and take out a package of gravlax.

"Sit, dear," I tell her, and she obeys with fidgets as I peel off a slice of salmon and offer it to her. She gobbles down the treat and licks my fingers in gratitude. I offer her a dish of cold water. She laps at the water eagerly. "Okay, sweet pea," I tell her. I close the door to the courtyard. Lily retreats to the laundry room, where she settles on a small Oriental rug. I retreat to the living room, where I have a window view of the mountains beyond. Today the mountains are wreathed in clouds. "Thank you, thank you," I say aloud to the Great Creator. Impending rain is welcome. Is it just my imagination that I hear back, "Little One, you're welcome"? If it is my imagination, I salute it. I practice trusting what I hear.

Recently I had a disturbing conversation with an older friend of mine. I've known her for thirty-nine years. She told me, "I think it's hubris to believe God listens to us. After all, dinosaurs were around millions of years. Why should God listen to a puny two-legged creature?"

Her skepticism caught me by surprise. For years I had piggybacked my faith on hers. Now she was telling me she didn't believe as I had always thought she did. The conversation left me with an unpleasant sense of dismay. I had to ask myself what I believed in apart from her disbelief. I came up with two short statements: *The words I need to heal? Just know this: God is real. The answer to my prayer? A listening God who knows I'm there.*

In other words, by simply asking, I am reminded on the deepest level that I believe in a God who is intimately concerned with my human affairs. This God speaks back to me when I ask. *And so I write L.J—Little Julie—and I pose my question, then listen for an answer.* The words I "hear" are wise and soothing. They feel wiser and more soothing than my usual thoughts. I trust that they come from a higher realm, a listening God.

Seeking our own highest wisdom, we must trust what we hear. As we ask for guidance, we will be guided, but we must trust the guidance that appears. "What should I do about X?" we query. The answer that comes to us may be far simpler than our intellect would suggest. When we try to figure out the answer to our problem, we habitually turn to our mind and not our heart. Yet it is the heart that holds our greatest wisdom. And so we must learn to query, "What does my heart say about this matter?"

It is a habit, for many of us, to listen with our head and not our heart. Make no mistake: the head is useful. But it is also often misleading. Clever, it takes a glib and superficial stance. The heart, by contrast, goes far deeper. It has wisdom our intellect may lack.

Faced with a decision, we do well to consult both head

Trust your Inner Guidance to reveal to you whatever it is you need to know.

—LOUISE L. HAY

Trust your inner guidance and follow your heart, for your soul has your blueprint and the universe has your back.

—HAZEL BUTTERWORTH

and heart. The head may urge us to be quickly decisive, while the heart urges us to pause and weigh the more subtle variables. The heart is partnered by intuition. Its counsel may not make rational sense, but instead may "feel" right. Listening to our feelings, we find a surefooted path. We are led, and led well.

A life led by intellect may be "smart" but shallow. Intellect frequently goes for a short-term win, while the heart is given to the long term. It is wise, rather than smart. As we work to lead a more heartfelt life, our intellect will fight us every step of the way. Of course it will. It is accustomed to being the boss, and now we are asking it to step aside, allowing our heart to be our primary guide. We are asking a different set of questions. Instead of "Is this the smartest route?," we are now asking, "Is this route the wisest?" The answers to these questions are often considerably different. Our heart may nudge us in a novel direction, while our intellect will dictate the tried and true.

Asking ourselves for the wisest, not the smartest, path, we find ourselves turning to our intuition. The hunch and the inkling become our friends. We come to depend on them. This new reliance on our hearts yields us a more comfortable life. No longer trying to be shrewd, we set aside the ego, which was so invested in being "smart" and "clever." In place of the ego, we find ourselves checking in emotionally. We do what feels right, and that turns out to be right after all.

Make no mistake: the intellect will not relinquish its kingpin position without a fuss. Hearing the heart's new power, it will round up all available weapons, and chief among these weapons is a well-placed doubt. The heart asks us to trust ourselves. The intellect tells us we can't be trusted. And the intellect has secondary tools: words used against the heart. Words like "naive" and "foolish." Comfortably ensconced as the leader, the intellect declares itself sophisticated and shrewd. It attacks the heart as "childish." It declares the heart "embarrassing." Its

scorn is scathing. Accustomed as we are to listening to the intellect, we must now teach ourselves discernment. We must ask ourselves just which voice we are listening to. The intellect is a bully. It wants to have its way, to win.

The heart has a gentle voice, calm but insistent. With practice, we learn to discern it. We ask ourselves, "Is this the voice of faith or of fear?" The heart is an optimist. The intellect is a pessimist. We are conditioned to listen to the intellect, which entertains itself with dark imaginings. The heart has a lighter tone, but it is not naive, foolish, or childish, as the intellect accuses. Rather, it is spiritual, connected to divine wisdom, to higher forces which intend us well. The intellect is harsh, snippy, cutting. The heart is tender. The intellect is sharp-edged, while the heart is soft. The intellect forces its way, where the heart cajoles. Faced with a decision, we must constantly practice listening to the heart. Depending on the intellect is a grooved habit. We must learn to ask ourselves, "Is my listening mere habit, or am I listening to something deeper and truer?" When we listen beyond habit, the heart speaks to us, and it does so softly and with persistence. As we listen to the heart, our life takes on a wiser and healthier tone. In time, we come to prefer it.

We can close our eyes, go within, and always receive the right guidance.

—SWAMI DHYAN GITEN

◄ **TRY THIS** ►

Choose a topic on which you need guidance. Pose your question and then listen for a response. Do not discount what you hear as "just your imagination." After all, your imagination is a wonderful thing.

THE QUIET OF SNOW

Lily and I are snowbound. The snow muffles all sound. Our silent world is peaceful. Our senses are attuned to

the quiet. According to the weather forecast, the snow will be falling all day and into the night. As I sit, writing, I sense that the quiet makes my guidance seem louder. There is something magical about being snowbound. Perhaps it is that by blanketing the outside world, it helps us connect more deeply to ourselves.

My phone shrills. I catch it on its second ring. It is my friend Scottie Pierce, calling me from San Diego.

"Snowbound?" she asks. She watches the Santa Fe weather, grateful to be somewhere warmer.

"Snowbound," I concur.

"It's seventy-five here," she confesses. "A sunny blue day. I'm watching the boats in the harbor."

"That sounds idyllic," I tell her, "but here it's very peaceful."

For many years a resident of Maine, Scottie admits to a fondness for snow. "Yes, snow is peaceful. All the world grows hushed."

"I enjoy the hush," I tell her. "It brings me a sense of calm."

"Yes, I remember," Scottie says. "I love the snow. It's the cold I hate."

To hear Scottie tell it, even San Diego is too chill for her. "It's cool but damp, some days out here—and you know how that damp cold feels."

"Yes, I remember it from my days in Chicago."

Scottie laughed appreciatively. "It's not like the dry cold in New Mexico or Arizona."

"No," I said, "it's not." I well remember Chicago's damp, bone-chilling cold. I lived there for eight years in my forties, and each winter seemed worse than the one before.

I am settling in to write when my phone rings again. I leap to answer it. The caller is Jacob Nordby, a writer I admire—a new friend.

"Jacob," I breathe. "I'm so glad to hear from you. I'm snowbound in New Mexico."

Jacob laughs a warm hearty laugh. "It's good to be heard," he allows. "And snowbound! Sounds exciting."

Jacob is an example in living the listening path. He is a careful listener to his environment and his friends, and he is habituated to listening to his higher guidance. An inspiring teacher as well as a writer, he encourages his students to do the same.

"I want to tell you how much I enjoyed your essay." I venture. "I read it twice and loved it both times. Your tone is so intimate and encouraging."

"Ah, that's quite a compliment. Thank you," Jacob responds.

"I did the exercises and found them wonderful," I go on. "I caught myself thinking that maybe I could steal them for use in my own teaching."

"Go right ahead," Jacob laughs again. Then he got down to brass tacks. "How's your writing going?"

I see no point in lying, so I confess, "It's limping along, a page or two a day."

"Same for me," Jacob admits. "Last year I wrote sixty thousand words and approved of none of them. I blew past my first deadline and started over from scratch. This time I think, 'You're getting warmer, closer to what you want to say.'"

I've now read three pieces of Jacob's work, and his style is so persuasive, so gently conversational, that I tell him, "You write brilliantly. Let yourself off the mat."

Jacob replies, "Your appreciation of my work comes at an opportune time. I need encouragement right now." He is forty thousand words into a new draft, listening carefully for his finale.

"Perhaps we all need encouragement," I think. To Jacob, I say, "I tossed a book out last year, too. It just wasn't

The art of writing is the art of discovering what you believe.

—GUSTAVE FLAUBERT

good enough. My intellect told me it was fine, but my heart knew differently."

"Ah, yes," breathes Jacob. He, too, tries to write from the heart, to be authentic. He believes, like me, that good writing is honest writing. In striving to be original, he need only remember that he is the origin of his work, and that as he is true to himself, he is by definition original. It is automatic, a matter of listening and recording what he hears. Much like listening to the heart above the head as we search for guidance and clarity, we can write from the heart. I am encouraged to remember this, and encouraged to know that Jacob and I are soldiering on a word at a time, connected across the miles.

Reminding each other to write from the heart, Jacob and I end our phone call. We are believing mirrors for each other.

Outside the window, the snow continues to fall, sparkling now in the light. Then the sun grows more insistent, pushing away the remaining clouds, leaving behind an azure bowl of sky. Without the muffling snow, sound returns, emerging crisp and clear. A raven caws its raucous cry low over the courtyard. A truck lumbers past.

◄ TRY THIS ►

To use one of Jacob's tools, "Run your hand across your life," noting "hot spots," arenas that are bothering you. Write a few sentences on each.

Now choose the arena that feels "hottest" to you. Can you listen for guidance on that topic? What do you hear?

READING AS LISTENING

"I think you should open your big prayer book at random," Scottie Pierce advises me. She is talking about my book *Prayers to the Great Creator.* "It will calm any anxiety—it does mine."

I find it difficult to imagine Scottie beset by anxiety. For thirty-five years she has pursued the listening path, sitting quiet every morning from five thirty to seven thirty. She cherishes her quiet time. She hears guidance, listening for the still small voice.

"I set my timer for twenty-one minutes and then sit in silence," Scottie relays. "After I sit, I read from Rumi, say prayers, and chant. I ask for my day to unfold peacefully, filled with joy and ease."

Encountering Scottie at any point during her day, I do find her spirit joyful—a far cry from anxious. She tells me that throughout the day, she checks in with her higher power, and that is where her spiritual reading calms her soul.

"I open the prayer book at random, asking to be shown what I need. I read one prayer, or sometimes several. All told, I'm quiet for an hour and a half or two. My house faces east, so I watch the sun come up. I start out in darkness and watch as the light comes. It's a very auspicious time."

Scottie's dependence on listening has made her brave. She is connected to higher realms, and that connection eases her life in this one.

"I'm never afraid," she has told me, and her lack of fear has made her a world traveler. In just the year past, she has cruised the Mediterranean, driven through Ireland, and taken a trip to Mexico to meet friends. Her trips fill her with satisfaction. Hearing about them—we stay in touch by email—fills me with awe.

"When I am traveling, I still sit quiet," Scottie tells

It's just a matter of our figuring out how to receive the ideas or information that are waiting to be heard.

—JIM HENSON

me. At Scottie's suggestion, I try sitting quietly, but find I have a greater sense of guidance when I am writing.

"Whatever floats your boat," Scottie comments wryly. She doesn't look down on my unorthodox meditation practice. To the contrary. She often urges me to "write for guidance," trusting completely that what I "hear" can be counted on—and acted on. "Higher forces," as I call them, take a lively interest in my human affairs. They listen to me, and I listen to them.

When I wrote the prayer book she speaks of, I did so daily, a prayer at a time. I wrote the prayers at night, in the calm of day's end. Reading them now, as Scottie advises, I find myself marveling at the prayers' authorship. At a few years' remove, the prayers give me pause. I listened and I wrote. I trusted what I heard. And now, reading them back, I find them encouraging and helpful.

"I can't believe I wrote them," I tell Scottie. "They feel inspired."

"Well of course they do—you were inspired," Scottie counters.

"Being inspired" is something that artists often speak of and sometimes experience. It is important to note that while we may "feel" inspired sometimes—perhaps a project comes into focus, an idea appears to us in a flash, or ideas rush upon us faster than we can write—we may also "be" inspired in a much less dramatic way. Books are written a page at a time. A writer's life is a life of dailiness, of adding words to the page. And as pedestrian as a single day or moment or sentence may feel in the moment, we may absolutely, simultaneously, be inspired.

Belief consists in accepting the affirmations of the soul; unbelief, in denying them.

—RALPH WALDO EMERSON

QUELLING ANXIETY

Today is a packing day. Tomorrow I fly to New York, where I will take meetings and see friends, and then from there, I will fly to London. There I will be teaching two days: an Artist's Way intensive. I have taught this course many times before, but each time finds me nervous. Every class is unique. I am hoping for the best: a class of eager students, good-humored and enthusiastic. In the past, London has offered just such a group, but I can't know before I meet them. In my experience, one bad apple out of a hundred can make teaching difficult. Instead, I hope for lively learners, students sophisticated enough to resist their own resistance. Such a class is exciting to teach—we can cover four days' curriculum in two days. From the front of the room, I watch faces light up as the tools work their magic.

But for now, it is time for nerves, not excitement. Packing always brings up a certain anxiety; I am taking what will be all the possessions I will have access to for the next two and a half weeks. I worry that I will forget something important. Intellectually, I know that I am going to a large city (New York) and then another one (London), where I will most certainly be able to

When it seems humanly impossible to do more in a difficult situation, surrender yourself to the inner silence and thereafter wait for a sign of obvious guidance or for a renewal of inner strength.

—PAUL BRUNTON

find whatever I need if I am indeed in need of something. And of course there have been the times when I did find that I needed something during my travels, and was able to find something not only practical, but special.

I'm often complimented on a patterned black coat I picked up in London on an unexpectedly rainy day.

"It's from London," I share.

"Oh, no wonder." The admirer will nod.

Listening for my higher guidance, I am encouraged and calmed about the upcoming trip. I am reminded of the fact that I am supported—by the places I will go as well as by my higher self. I make a long list of what to take, beginning with passport and cash and working my way through the rest. Satisfied that I have packed everything, I close my suitcase.

The travel day from Santa Fe to New York is long—longer than the trip from New York to London. Living in the mountains means views and songbirds, adobe and green chili, clear, quiet sunny days and booming, dramatic storms. It also means that for my busy travel schedule, with few direct flights out of Santa Fe, I have come to know the Dallas/Fort Worth airport—my frequent layover location—very well.

Some of my friends travel often; my friend Scottie not only travels the world but keeps multiple homes in different parts of the country and moves among them with ease. Other friends choose not to travel, preferring to stay put in New York or New Mexico or Los Angeles. I note that while travel always seems to unearth a familiar anxiety for me, I still always choose to do it. I'm currently in the process of scheduling trips to New York, Chicago, London, Paris, Rome, Edinburgh, and Santorini. Not the actions of someone who doesn't want to travel, I note to myself. And so, I listen for guidance,

hearing "All will be well. You have much to share and your students are grateful to receive it." Calmed, and starting to feel excitement—I do love visiting London—I set the alarm and head out to meet the car to the airport.

Waiting at the gate, I call my friend Gerard Hackett to confirm our lunch plans for the next day in New York. Checking in with Gerard, I find myself optimistic. Gerard himself is optimistic, and his mood is contagious. Gerard asks me how things are going, and he patiently listens as I reply.

"London should go well," Gerard says.

"Yes," I manage.

"It has in the past," he insists.

"Yes, it has," I allow.

"What will you do for fun?" Gerard queries.

I tell him I will walk, enjoying London's neighborhoods.

"Well, I look forward to seeing you tomorrow," he signs off.

As I board the plane, I am struck by a sense of gratitude. "I am lucky to see the world and to regularly see my far-flung friends," I think to myself. I will arrive in New York and settle into my familiar hotel. Sleeping in, I will order a room service breakfast of oatmeal and coffee. I will write my Morning Pages and then I will make my way downtown for a late lunch with Gerard. I notice how my thoughts have moved from anxiety to gratitude, even excitement. Is it because I listened for guidance from my higher self, and what I heard was encouraging? I believe it is.

We have all a better guide in ourselves, if we would attend to it, than any other person can be.

—JANE AUSTEN

> ◄ **TRY THIS** ►
>
> Choose a topic on which you frequently experience anxiety. Try, if you can, to choose an area where you have historically struggled to find peace. Now ask your higher self for guidance on this subject. Listen for what you "hear." You may wish to write out this guidance. Is your guidance calmer, more encouraging, and more optimistic than your anxious thoughts might have suggested? Do you sense a shift from anxiety to gratitude, calm, or optimism as you listen for encouragement?

HINTS OF SPRING IN SANTA FE

I am back in Santa Fe after—yes—a smooth, productive, and enjoyable trip to London. My students were indeed witty and energetic. Their humor was contagious, their enthusiasm inspiring. Our British hosts were delightful, putting us up in classic English luxury and treating us to festive meals and jaunts around the city. I return with a sense of optimism, after taking in the fresh sights and sounds, and a sense of accomplishment, knowing that my students left the weekend with tools and excitement.

Inner guidance is heard like soft music in the night by those who have learned to listen.

—VERNON HOWARD

Back at home, the mountains are lit gold by the setting sun. We had a warm day, and the snow on their peaks has largely melted. At the outer gate to my courtyard, a hearty lilac is blooming. When I take Lily out for a walk, a plump lizard darts across our path. It is the striped variety, not the delicious gray, so Lily ignores it. We climb the stairs to our dirt road. I hear the purr of a car approaching, and I tug Lily over to the shoulder. The driver passes with a merry wave. I love Santa Fe.

Before I went to London, the trees were wintery bare. In the two and a half weeks I was absent, they have

sprouted bright green leaves, snow notwithstanding. The flowering trees, damaged by the hail, are in a hurry to shed their blossoms and get on with the business of summer foliage. I, too, am eager for summer. My roses and lilies will make for a festive garden. I will sit out at twilight after the heat of the day has passed. Fireflies will flicker on and off until nightfall.

Just for today, dusk feels elongated. Light holds until eight. Passing through the plaza, Santa Fe's centerpiece, I greet a friend. He is bundled up.

"It's staying light longer," he greets me. "Ten degrees warmer and I can shed my outer layer."

"Yes. Yes, we can," I agree. I, too, am bundled up.

Back at home, I hook my coat on my coatrack. I check the thermostat and crank it up a few degrees. Without my coat, the house is chilly. The phone rings. My caller is Scottie, who recently had oral surgery. She is sounding better and stronger than she had a few days before.

"I'm healing," she announces. "Every day I'm better. I can feel it."

"You sound like yourself."

"I'm not supposed to talk very much."

"Your voice is steadier."

"The surgeon called me this afternoon and warned me not to overdo it. I just wanted to hear how you were."

"I'm good. I had a happy day's writing."

"That always cheers you up."

"Yes. Yes, it does. And I took Lily for a long walk. The lizards are out."

"Already?"

"Yes—already."

"My voice is starting to go. I'd better get off."

"I'll call you tomorrow."

"Great." We hang up.

I admire Scottie's resiliency. She meets life's challenges with courage and good humor. Her surgeon has told her

to ice her cheek every twenty minutes. I would resent such an instruction and rebel, but Scottie complies without complaint.

She tells me, "I'm bruised and swollen. I'm just grateful I've never been abused."

Leave it to Scottie to search for—and find—a silver lining.

Now it is time to wind down for the night. I have been going to bed earlier and getting up earlier, wanting to have a full day. At six A.M., I appreciate the songbirds' early serenade. When the wind picks up later in the day, I remember to tell myself "soon it will pass." And when it does pass and the house feels quiet except for the ticking kitchen clock, I relish the relative silence.

During my absence, I counted London's sirens. The city sounded loud to me. I found myself longing for Santa Fe and the syllables of nature. Now, home, I miss the city's cacophony. My ears have grown accustomed to the sound of urban life. The listening path is led a sound at a time.

◄ TRY THIS ►

Take yourself to an unusual location. It doesn't have to be out of the country—it can simply be into a place that you don't normally go. Listen to the soundscape and note how it is different from what you are used to listening to. How does a new soundscape make you feel? What insights does it bring?

PAINTER AS LISTENER

I pick up the phone and call Pamela Markoya, a Santa Fe artist I have known for several years. I know that she

approaches her art through listening, and I ask her to lunch. I believe that she actively listens to her higher self in the process of creation, and when we meet up later at a Japanese restaurant, she confirms my belief.

Pamela carries herself with a model's grace. Clad in tight black jeans and a crimson top, she cuts a striking figure. Silken-haired, pale-skinned, she is a beauty. All eyes follow her as she makes her way to her table.

"Hello, good to see you," she greets the restaurant's owner, a slight, striking Japanese man. "How are you?"

"Good to see you," the owner responds.

Pamela takes her seat and explains, "I eat here all the time. Everything is delicious. Everything is fresh. The sushi is fantastic, but the bento box is excellent—as is the teriyaki."

I finger the menu, which is in Asian-looking script. My order will be simple: miso soup and a California roll. Pamela's order is more complex. She knows the menu by heart. Swishing her mane of auburn hair to one side, she orders. I ask her to talk to me about her practice, and the role listening plays in it. She gamely plunges into the topic.

"My practice is to sit, breathe, and listen," she starts off. "My writing is an art form meant to be shared. I write love letters to my beloved, with the knowledge that they will be read. Literally, for writing, I put the ink pen to the page and listen to hear the words—and write what I hear. It is as though my listening ear is connected to the ink. I could be surprised, and often am, at what's written." Pamela sips at her tea and gathers her thoughts. She continues. "I stop writing when I don't hear anything. The voice unfolds one word after another, distinctively. It has intonation, lyricism, and color. Often there's humor, and I really 'hear' the letters coming through with humor and levity."

Our miso soup arrives. As promised, it is fresh and

delicious. Pamela ladles a spoonful, then sets down her spoon and continues her thoughts.

"When I paint," she says, "I breathe and clear everything. Although it is a visual art and informed by what I see, I listen to the brush, and there's a very clear direction. In the process of mark-making, I rarely change anything. The mark-making is a language I listen to." Pamela laughs. She continues lightly, "Yes, I'm a good listener. I think listening is how we fall in love. The resonance of another's energy, listening to the tone of voice beyond the words—I think Cupid comes with big ears. I think love asks us to listen—to the words, to the space between the words, the silence. We are asked to listen beyond our comfort zone, to listen into the unknown, into vulnerability. For me, it's in the listening that I can have the strength, the willingness, and courage, to go into the dance of love, the practice of art."

Two platters with our sushi arrive. We eat for several moments in silence. Then Pamela speaks again. "No listening, no love," she says. "Listening places me into the form of spiritual connection I have with people in my creative practice. Yes—no listening, no love, no connection. And art is about connection."

We are ravenous and gobble our sushi. We want more, we decide, so we order a second round. Pamela takes advantage of the pause in our meal.

"I listen to the universe tell me things," she says. "Right after I got divorced, I was in the middle of an emotional emergency, and I didn't understand how much I needed self-care. I began to notice sirens—police cars, fire engines, ambulances. A siren was a sign for me to stop, breathe, check in with my body—really get into the moment. I continue this practice today, ten years later. I listen, and I find I have an interactive experience with the universe. When I hear church bells or chimes, I stop and pray. Through listening, the universe is my teacher."

Pamela shares a final thought. "Listening has access to the ancients. The myths, the angels, the spirits, the mystics. In listening, there is a timelessness. They say seeing is believing—I say listening is believing."

◄ TRY THIS ►

Listening connects us to higher realms. With pen in hand, ask yourself the question, "What do I need to know?" Write out the answer that you "hear." It is the voice of a wiser self. Take its advice to heart.

MINISTER AS LISTENER

"I kept thinking we were on at twelve thirty, not twelve," apologizes minister Brendalyn Batchelor, arriving late for our scheduled lunch at Love Yourself Café. She wears a brightly striped top over turquoise harem pants. Her blond hair falls in a silken curtain. She hardly looks like a minister. Twenty-five years in the job has earned her the right to casual apparel.

"I love your hair," I tell her, but she turns the compliment aside.

"I'm getting it cut tomorrow."

"Ah, well."

Brendalyn plumps a fat pillow onto the banquet. She glances at the menu but already knows her choice: a vegan specialty, the skillet—sweet potatoes, kale, onions, mushrooms, and avocado. She places her order. I order a bowl of oatmeal with fruit.

Waiting for our meals, I corner her with questions. "How important is listening to your spiritual path?" I ask her. The question piques her interest.

"I think it's essential," she replies. "I'm always listening

May you always find your
intuitive voice and may the
language of your intuition
sing.

—JODI LIVON

for the still small voice." She taps her chest, as though knocking for a response.

"How do you listen?" I ask her, picturing her at prayer.

"Well," she says, "I meditate twice a day, for an hour each time. I get quiet and I pay attention to the sensations in my body as they bubble up. I don't do anything special. I just notice what occurs."

Our meals arrive, and Brendalyn focuses on her food. I wait patiently for her to continue. Between bites, she says, "I listen to the silence, and I get messages. I receive guidance about what to do next."

I pause and spoon down my oatmeal. Then I ask, "So you focus on listening and your attention is rewarded?"

"Yes," says Brendalyn. "Exactly. I heard a phrase recently that describes my experience. The speaker said that spiritual listening is 'listening with the ear behind the ear.' I heard that and thought, 'That's it exactly.'"

"Do you pray for guidance?"

Brendalyn sets down her fork. She explains, "I listen within. I don't believe in a god outside myself." She begins to eat again, picking up a bite of sweet potato, then a morsel of avocado. She eats mindfully, as Thich Nhat Hanh advises.

She elaborates: "I am part of God, and God is part of me." Her silken bob swishes as she nods agreement with what she declares.

"I believe in a listening god," I tell her.

"And I believe in listening always," Brendalyn responds. She spears a last bite of sweet potato, leaving me to ponder her concept of a god within that she listens to at all times.

"So if I believe in a listening god, you believe in a talking god?"

"Something like that. My messages are practical—I hear what to do next." Brendalyn describes what might

be called a spiritual radio kit. Her job, as she sees it, is to "stay tuned."

"I don't believe in a god outside of myself," she explains. "Instead, I believe in a god within."

"So when you pray, you're praying to yourself?"

"Something like that. I don't believe in an outer god with a will for me."

"But do you believe your inner god has a plan?"

"I believe I learn a plan as I listen. As I said before, I am a part of God, and God is a part of me. Listening is key."

The soul's rainbow has more colors than the sky's stars.

—MATSHONA DHLIWAYO

◄ TRY THIS ►

Write out a list of five traits you were raised to believe God had. Look over your list. What traits, if any, do you want to keep? Now write a list of five traits you would like to believe about God. Your ideal God would be . . . kind, funny, wise, gentle, generous? . . .

LISTENING TO FITNESS

Michele Warsa, a physical trainer, believes that listening "is everything; a key to my work." Slim, svelte, beautiful, she is a walking advertisement for her theories. "I listen to keep my clients from getting injured. They tell me when they experience discomfort. I listen, and adjust their routine. Of course, everyone wants to be thinner, but that takes time and care. I go slowly, and the results pay off."

A fervent walker, Warsa walks daily and encourages her clients to do the same. "Walking is good for the back," she posits. "Even five minutes helps." She continues, "Any exertion is good—five minutes, ten minutes. The key is

frequency. Don't think you need to go a long time. Every little bit helps."

A half hour's workout with Warsa begins with cardio: ten minutes on an exercise bike, five minutes on a treadmill. Next is mat work with weights. Follow that with balance work, and end with stretches. Accompanying all this is Warsa's stringent optimism. She notes the smallest gains.

I have worked with Warsa three times a week for six months. My routine, difficult at first, has become easier. My weights are heavier and my repetitions quicker. Warsa notes that while I haven't lost weight, I am more toned. The mirror tells me this is true. I want to push ahead, but Warsa is reluctant to tax my body. Listening to my cues, she holds to a half hour, believing that easy does it.

"How is your back?" she asks. I happily report that my back is pain-free. Before I worked with her, I suffered chronic back pain. The muscles on my right side were tighter than the muscles on my left. Warsa's stretches evened them out. "Now, if your back starts to hurt again, I want you to do our stretches," she instructs. "And I want you to tell me. I'm a good listener, but not a mind reader."

Intuition is seeing with the soul.

—DEAN KOONTZ

"You could have fooled me." In our time working together, Warsa has often intuited an ache before I articulate it. Perhaps I sigh or moan. The faintest whimper catches her attention. She is listening, as Brendalyn has put it, with "the ear behind the ear."

Her body work, for her, is a spiritual path. She tunes in first to her higher power and then to her client. She is led forward a step at a time. A true healer, she feels compassion for those she works on and with. A beauty herself, she labors at unlocking the inner beauty in others. Patient, tolerant, and tender, she works slowly and carefully. She asks questions and listens with care to her

client's response. Gentle and efficient, she leads the way to greater health. Listening to the subtle clues that her clients offer her, she charts progress by tiny increments. Her optimism about progress instills optimism in those she works with. I thank her for her care, but she turns my thanks aside. "I care," she explains. Her care is evident—and healing.

<div style="border:1px solid">

◄ **TRY THIS** ►

Slow your pace and listen for revelations. Acknowledge that *hurry* equals *worry*, and *slow* equals *know*.

</div>

REALTOR AS LISTENER

Manhattan Realtor Suzanne Sealy phones me "just to check on me." We were friends a decade ago when I lived in New York, and we have continued our bond long distance. Thirty-eight years a veteran on a spiritual path, she leads a successful life as one of Manhattan's top Realtors. She combines modesty with experience, a winning combination, and she attributes her high-powered career to an ability to listen. She matches her offerings to the needs and desires of her clients, both spoken and unspoken.

"I listen to their reactions and I watch their body language. There are cues and clues about their preferences. Take this afternoon. There was a street fair on Lexington Avenue, and I was showing a third-floor, rear apartment on 92nd and Lexington. The apartment overlooked the townhouse gardens. It was quiet and peaceful. The couple I showed it to responded to the quiet. I listened to them, and they listened to the luxury of a quiet apartment in a

noisy city. The wife moved room to room, mentally placing furniture. The husband just stood still and soaked up the silence. I let the apartment speak for itself. The windows were open, but you couldn't hear a thing. There was joy in the silence."

Suzanne paused, then continued thoughtfully. "Listening means giving your full attention. Never be in a hurry to finish the conversation. There is an art to telling your client to talk more, and it takes patience to listen as they do talk more." Suzanne paused again. She wanted to be precise. She went on. "The best thing I heard about listening is the way to make a new friend. Ask a question, listen to the answer, and then ask a follow-up question. That confirms to the other person that you are truly listening. Listening is reading between the lines, listening to what they didn't know they were saying." Suzanne paused yet again, then continued. "Listening in real estate is very, very important. Sometimes listening not with your ears but with your eyes. Their body language speak volumes—open or closed. A lot of my success lies in my listening."

As I listen to Suzanne, I hear her acute ability to take in the whole picture of a client and then to interpret it through her own intuition. Choosing a home is exceedingly personal, and as she brings people and homes together, a higher hand—call it inspiration, serendipity, or kismet—is at play when a match is made. Yes, the level of sunlight and the number of bedrooms must match expectations. Yes, the price and location and style of home are carefully incorporated. But what "feels like home" is more elusive, and Suzanne's ability to listen for this gentle and powerful chemistry—human to space—is her personal and mighty gift.

◄ TRY THIS ►

Recall to mind an interaction in which you felt guided. You were wiser than your normal self, and you experienced a sense of direction in the exchange. Like Suzanne, you listened and found yourself led.

CHECK IN

Have you kept up with your Morning Pages, Artist Dates, and Walks?

What have you discovered in consciously listening to the still small voice?

Do you find that you feel more connected to yourself?

Did you experience resistance? Were you able to resist it?

Name one memorable experience of listening. What was the aha that came from it for you?

LISTENING
BEYOND
THE VEIL

—ⲟⲟⲟ—

Seeing death as the end of life is like seeing the
horizon as the end of the ocean.

—DAVID SEARLS

This week we will listen deeper yet, and we will reach to connect to those who have passed on. As we are now in the habit of listening—to our environment, our fellows, and our higher selves—we will find that this next step is not as much of a reach as we might assume. We will find that those who have crossed through the veil may feel closer than we expected, and that if we can resist our own resistance, listening for them can be both casual and gentle.

CONNECTING TO THE WORLD BEYOND

The fourth tool of the listening path asks us to listen to the world beyond the veil. This requires spiritual openness. Unlike many societies who revere their ancestors and ask them for guidance, our society tends to think that ancestors—and deceased friends—are beyond our reach. "Not so," says the listening path. If we are open to it, we can hear from those who have passed on. All that is required is the willingness to experiment. As we reach out to our deceased loved ones, they reach back to us. It is not uncommon to hear them speaking as they spoke in life. All that is required is that we open the door. And so we write: "Can I hear from X?" The answers come promptly and easily. We "hear" our loved ones speaking, sometimes so easily that we doubt the communication can be real. But what if it is real? "Do not doubt our bond," we are chided. And so we are asked to set our

Death ends a life, not a relationship.

—MITCH ALBOM

skepticism aside. We are asked to be vulnerable, childlike, and open. When we cooperate, we are rewarded by further communiqués.

I speak to people who have passed on as a daily practice. As I reach out, they hear me and respond. The first is a spirit named Jane Cecil, a close friend and advisor during her lifetime. I spoke to her daily and was grateful for her wise counsel.

"Can I hear from Jane?" I ask. I hear back promptly.

"Julia, I am right at your side." She continues, "You are led carefully and well. There is no error in your path."

Having greeted me and set me at ease, Jane is ready to be more specific. She turns her attention to the issue at hand. "Your book is going well," she tells me. "Keep a steady pace. Do not second-guess yourself."

Jane's messages are brief and direct. They are soothing, having the uncanny knack of addressing precisely my current concerns. Sometimes they pinpoint a concern before I have identified it. Jane may say, "You're clean and sober. You'll continue to be firm in your sobriety." Until Jane spoke, I was not consciously aware of my nagging worry about drinking. But there it was. Jane's wisdom surpassed my own.

After "talking" to Jane, I turn my attention to another friend, Elberta Honstein, a breeder of championship Morgan horses. Elberta's communiqués retain the flavor of the horse show ring. "Julia, you are a champion," she may tell me. "No obstacle is too much for you. You are strong. I give you stamina and grace."

Invisible threads are the strongest ties.

—FRIEDRICH NIETZSCHE

Like Jane's, Elberta's messages are reassuring. They tackle what I think of as my "hidden concerns." I worry that I am not enough, but Elberta assures me that I am plenty. She calls me a champion—horse talk for "excellent."

Elberta, like Jane, urges me to trust the reality of our ongoing bond. "You reach to me and I reach to you,"

Elberta reassures me. "You talk to me and I talk to you," she asserts. "We are as we always were," she pronounces. "Our bond is eternal."

Faced with such reassurances, I find myself trusting. When I write out what I "hear," I find myself thinking that more people should try my simple tool.

Ask to "hear" and then listen. It was need that triggered my reaching out to my friends. In life, we talked daily. In death, the habit continued. There were topics I could only raise with Jane, topics I could only raise with Elberta. My need for continued contact—and advice—led me to listening. I would pose the question "Can I hear from Jane about X?" and then I would listen as if she were right in the room with me. I found that she was with me. Pen in hand, I took dictation, writing from Jane "about X."

It was the same with Elberta. In her lifetime, I frequently asked her to pray for me. Nervous about teaching, I would call her. "Stick me in the prayer pot," I would request. Elberta's prayers gave me confidence. I could feel their steadying impact. When she died—suddenly, unexpectedly—I posed my request to the ethers. "Elberta, please help me." Pen in hand, I would listen for her response. "You will do very well," promised Elberta from the ethers. "I give you wisdom, stamina, and grace." Writing down what I "heard," I found myself marveling at Elberta's poise and dignity—the same in death as in life.

Both Jane and Elberta retained their characteristics. They were recognizably the "same." When I reached to them, they reached back to me, displaying a heartening eagerness to connect. Their messages were always encouraging. I came away from our contact feeling seen. It was as though I had enjoyed a happy visit during their lifetime. I had the sense that they were not really gone. For some time, I kept my visitations to myself. Our contact

Realize that everything connects to everything else.

—LEONARDO DA VINCI

felt real to me, and I didn't want to experience doubt or skepticism from another. Over time, my conviction that we were actually in contact grew, not lessened. I found myself confiding to a few select friends our ongoing bond. "Jane said," I would say, or "Elberta mentioned . . ." To my relief, my friends did not scoff at my revelation. I had feared that I would sound too woo-woo. When I confessed this fear, I was greeted with understanding. As one friend remarked, "Julia, woo-woo is where it's at."

"You're lucky to have direct contact," Scottie Pierce tells me. But I feel luck has little to do with it. Open-mindedness does. If more people would experiment with making contact, communication with deceased loved ones would be commonplace.

"But, Julia, what if your responses from the afterlife are just wishful thinking?"

If so, my "wishful thinking" leads me in a positive direction. There can be no harm in the positive. The contact bolsters our self-worth. As we strive to be worthy of our messages, we become better, stronger people. Our "wishful thinking" leads us forward.

It has been three years since Jane passed on, and two years for Elberta. I began writing to them promptly and I now have several years' worth of messages. Leafing back through my journals, I find that their messages stay essentially the same. They are upbeat and reassuring. They urge me to have faith, to trust that I am on track, well and carefully led. I find no dire warnings. Perhaps their guidance keeps trouble at bay.

"Julia," I hear from Elberta, "your creativity is intact."

"Julia," Jane echoes her, "you are as strong as ever."

I sometimes read Scottie Pierce what I have been told. When I share with her that I am confused over some issue in my life, she will ask me, "Did you ask your guidance? What did Jane and Elberta say?" Over the years, Scottie has come to trust my guidance as I do. For my part, I find

myself able to talk to her of messages. She listens to me closely and never scolds me for being too woo-woo.

My believing mirror Sonia Choquette is another confidante. When I tell her Jane's or Elberta's take on something, she urges me to trust their input. When I confess to her that I find it easy to contact them—so easy I sometimes doubt our contact can be real—Sonia, a third-generation psychic, scolds me. "Don't think it has to be hard," she warns me. "Communication with spirits is easy and natural. Don't think you need a lot of elaborate schooling." And so, un-schooled but open-minded, I persist in my contact. I ask, "Can I hear from Jane? Can I hear from Elberta?" and I listen for their response. They are an integral part of my listening path. I have learned to trust that their messages are real.

As we begin to explore this contact, we will at first be tempted to discount the messages we hear. "Shouldn't it be more difficult?" we wonder. Shouldn't we have to struggle to "hear beyond the veil"?

No, insists Sonia Choquette.

What matters here is our clear expectation that we can and will hear the voices of our beloveds. Our pure yearning for contact builds our bridge to the beyond. We pray to hear, and we do hear our loved ones answering our call. Their messages are reassuring. "Do not doubt our bond," we are told.

And so we must learn to doubt our doubts. We must trust, as words form in our consciousness, that the words forming come to us from beyond. We listen and take down what we "hear." Our loved ones speak to us fondly and calmly. Unlike us, they do not doubt our connection. Rather, they welcome it—and us. Their words come to us with clarity. We take down their messages and find ourselves comforted. Their loving intent is palpable. A sense of well-being comes to us. As we reach to the ethers to our loved ones, they in turn reach back to us. We are loved,

The world is so empty if one thinks only of mountains, rivers & cities; but to know someone who thinks & feels with us, & who, though distant, is close to us in spirit, this makes the earth for us an inhabited garden.

—JOHANN WOLFGANG VON GOETHE

Staying vulnerable is a risk we have to take if we want to experience connection.

—BRENÉ BROWN

and we can feel that love even after they have crossed "through the veil."

"Can I hear from X?" we query, and it is as though we have placed a phone call. X answers us. "You are in my custody, safe and protected," we are told. Pen to page, taking dictation as we listen, the loving message unspools through the written word. There it is in black and white: contact!

◄ TRY THIS ►

I invite you to try woo-woo. Select a friend or family member to whom you felt particularly close during their lifetime. Ask the simple question, "Can I hear from X?" Be prepared for a quick response that yes, you can hear from X. Listen for what X has to tell you. Very often, you will find it reassuring, as though you were picking up the thread of a cherished conversation. The message may be brief but direct. In all likelihood, it will leave you feeling loved. Thank your correspondent for getting in touch with you. If you wish, promise to be in contact again soon.

LISTENING THROUGH THE VEIL

Susan Lander has curly brown hair and big eyes. She looks grounded, and she is grounded. She makes her living as a medium and psychic, talking to and receiving messages from those who have passed on. She is a believing mirror as I share my experiences reaching beyond the veil. Her easy confidence on the topic is contagious. She believes that the afterlife, far from wishful thinking, is every bit as real as the life on earth.

I am excited for my conversation with her. I pick up

the phone, reaching her in Florida. Our conversation bubbles merrily as I ask her to talk about listening beyond the veil.

"For me, there are different dimensions of listening," Susan explains. "There is listening in general conversation. There, I try to not be too superficial, but I often catch myself listening to respond, rather than listening deeply. It's challenging because I love to share experiences. When I catch myself doing this, I know it means I'm not listening to listen—I'm listening to respond. I'm a huge extrovert—I love talking."

As if in proof, she rushes onward. "Last year I worked really hard to actually really listen. It's respectful to really be present for what other people say. My favorite person to talk to is a speech pathologist. She's very aware of the patterns of talking. She sets a pace of stopping and listening. She sets the pace of our conversations. Actually, she slows everything down—it's really relaxing. When she's speaking, I'm present for her, and vice versa. That's Susan the earth person."

Susan slows to a meditative pace. Her words reflect her shift in consciousness.

She explains, "Then there's Susan the medium. It's really different. The mediumship process involves setting ourselves aside to fully listen to Spirit. The goal is for me to be off to the side and just be a conduit for the messages of Spirit. The Spirit messages are multisensorial. I hear, see, and feel their messages. My whole body is engaged—not just my brain, as in general conversation. The important part is, I use my whole body instead of just intellectual conversation."

Again, I am reminded of the difference between listening with the head and the heart. What Susan is describing seems to be the combination of both.

Susan continues: "When I'm listening to Spirit, I'm

We are all connected . . . you can no more separate one life from another than you can separate a breeze from the wind.

—MITCH ALBOM

aware that it's very sacred. I am being trusted to transmit their messages, so I listen really hard. It's a huge responsibility and gift. These are people's loved ones. I'm doing the listening for the people on earth because they can't listen as well. I've got to be on my game one hundred percent. I've got to be listening. I turn into a giant psychic antenna."

Susan pauses, gathering her thoughts. She goes ahead carefully. "It's also extremely rewarding and feels wonderful. For example, I now see horses from your friend the horse woman. It's a postcard from her—sending God, the divine, down to earth."

I smile, thinking of Elberta, and knowing that she is close.

Things we lose have a way of coming back to us in the end, if not always in the way we expect.

—J. K. ROWLING

◄ TRY THIS ►

Close your eyes and imagine yourself in a special locale. Walk into the locale imagining that you have a rendezvous with your spirit guide. Who and what do you see? Most important, what guidance do you hear? Your guide is wise and gentle. Allow yourself to take in spiritual advice. Thank your guide for its guidance and return to your normal consciousness, knowing that you have established contact and that you can visit with your guide again whenever you need its input.

CHECK IN

Have you kept up with your Morning Pages, Artist Dates, and Walks?

What have you discovered in consciously listening for those "beyond the veil"?

Do you find that you feel more connected to those who have passed?

Did you experience resistance? Were you able to resist it?

Name one memorable experience of listening. What was the aha that came from it for you?

LISTENING TO OUR HEROES

———∞∞∞———

Listen with the will to learn.

—UNARINE RAMARU

This week we will build yet again on the tools we have experimented with, now reaching out to our heroes. We often wish we could have met someone—animators may wish they could have met Walt Disney, or lyricists may wish they could have met Oscar Hammerstein II—but we will find that with a little openness and imagination, we may be able to connect with these heroes more easily— and more intimately—than we might expect.

LET OUR HEROES SPEAK

We have now arrived at the fifth tool of the listening path. By now, you are well prepared to attempt it. You have practiced listening to yourself and others. You have listened carefully to both sides of the veil. Most recently, you have listened to spirits that you love and revere. Now you are going to try listening to spirits that you admire but don't know personally—in short, your heroes.

Just as reaching to our beloveds feels surprisingly easy, so, too, reaching to our heroes is simple—not at all hard. Again, what matters here is our intention. We must have a pure yearning to make contact. Our heroes respond to our clarity. We make contact first with ourselves, answering the question "Who, truly, do we admire?"

Our heroes are personal. When we inquire of ourselves just whom we admire, the answers may surprise us. We do not always admire those we *should*. Instead, we admire those we *do*. Our heroes match our value system.

One way to remember who you are is to remember who your heroes are.

—WALTER ISAACSON

If we value education, our hero may be a great teacher, like the late Joseph Campbell. If we value daring, we may find a hero in Amelia Earhart. If we have a love of horses, a hero may be the writer Dick Francis. And so it goes. As we name—and claim—our heroes, we feel a connection. Taking that spark of connection one step further, we may ask for our hero's guidance. It will come to us, often surprisingly nimble in addressing our precise needs.

Make no mistake: our heroes remain our heroes as they answer our calls. Their response to us is loving and accurate. If we name them with clarity, they in turn pinpoint our needs—even if these needs may be unspoken.

I write to Bill Wilson, co-founder of Alcoholics Anonymous. I admire him for daring to found a movement. He needed to trust that what worked for him could work for others. It was an act of tremendous courage to write out the steps he himself had taken as a blueprint for recovery from alcoholism. He dared to think that what had saved him could save others as well. He became the floor sample of his own tool kit. Millions have now followed his example.

Life is built upon the labors of my fellow men, both living and dead.

—ALBERT EINSTEIN

Wilson responds to me promptly and warmly. I am told that my getting people to write is a great service. I am reassured that there is a place for me and my work—addressing a hidden concern that my work is outmoded. I find Wilson to be quite accessible. I am grateful for the positive mirroring he provides. I write: "Can I hear from Bill Wilson?" I "hear" the following answer. "Julia, you are doing well. Your patience will be rewarded. There is no need for anxiety. You are on track and steady. Do not despair. There is no need for you to worry. Ask me for guidance and inspiration. I will lead you. You will find a voice, and it will be firm and steady. You do not need to fret. You can write, and write well. Open your heart for guidance and allow yourself to be led."

On a more formal note, I address Dr. Carl Jung. Carl

Jung dared to observe, name, and describe the workings of the mind. Before his work, the mind remained a mystery. After his work, we had terms. We encountered not a vague something, but our "shadow." We had archetypes to describe what before had been largely mysterious figures of the mind. "Name it and claim it," Jung challenged us. We followed his lead, and our psyche was no longer terra incognita. Observing the mind with objectivity, naming what he saw, Jung mapped our mental terrain. His was a heroic undertaking. He faced down scorn and then the contempt of his peers. His bravery gave us a road map. Our minds could now be explored with impunity. Jung led the way.

His responses are cooler and more cerebral. Like Wilson, he takes pains to assure me that my work is important. I am reassured by his attention. I respect his work and I am reassured that he respects mine.

I write to Dr. Jung and I hear back. "Ms. Cameron, you are on track. You have much to offer. You can express yourself well. Right now you are replenishing your stocks. There is much to be said for a deep, quiet life. Read Anaïs Nin and you will fare better. There is much goodness afoot for you."

The mention of Nin caught me by surprise. I knew, of course, that Jung and Nin were contemporaries, but his enthusiasm for her was unsuspected. On the strength of his recommendation, I ordered a volume of her work. Forty-five years had passed since I last read her writing.

Life shrinks or expands in proportion to one's courage.

—ANAÏS NIN

Thinking over Jung's connection to Nin, it began to make more sense to me. Her diaries were a detailed account of her daily life. Jung encouraged his patients to be similarly forthcoming. He ministered to those brave enough to dare self-disclosure. I find myself thinking of one of his patients, an alcoholic for whom he held out a dire diagnosis. A "vital spiritual experience" was necessary to produce a cure. His involvement with this patient ran

deep. No wonder that he was drawn to the populace of Nin's personal life. Her account was right up his alley.

Wilson and Jung enjoyed a personal correspondence. Jung endorsed Wilson's conviction that alcoholism required a spiritual cure. For his part, Wilson was deeply moved by Jung's attention to what was then a fledgling movement—that would, in time, become the millions-strong Alcoholics Anonymous.

Writing to both Wilson and Jung, I experience a deep sense of personal guidance. I am on track, both men say, and I, for one, am glad to hear it. It is a little-known fact that Wilson "reached through the veil" himself during his lifetime, practicing séances as a regular part of his spiritual life. He was reluctant to make public his interest in the occult for fear it would be considered too woo-woo. He didn't want AA to become branded as too otherworldly. It was my privilege recently to read thirty-some of Wilson's personal letters. This sampling revealed his deep and ongoing conviction that the afterlife was accessible—and helpful! When I first wrote to Wilson, he replied that he was "delighted" that I "shared some of his interests." Thus encouraged, I made writing to him a regular practice. For his part, he answered my correspondence with warmth and vigor.

Writing to our heroes, we forge a connection that gives us both courage and guidance. Hearing our heroes' input on our personal affairs, we come to know that our lives matter. We are assured that our dilemmas are worthy of the highest attention. Far from being petty, their resolution is profound.

At first we may worry that we are bothering our heroes, but as they answer our requests for their input, we come to realize that they are not bothered—rather, they are deeply interested in our affairs. As we ask for guidance, we are given guidance, and the guidance is wise. As when we spoke to our higher self, the counsel we receive

Our chief want is someone who will inspire us to be what we know we could be.

—RALPH WALDO
EMERSON

may be simple and direct. Above all, it is loving. It is as though our heroes are now even more heroic. Our heroes mentor us, but they in turn may be mentored by the Great Creator.

There is no question too petty for their attention. They seem to possess an infinite store of both wisdom and patience. "What should I do about X?" we query. Their response takes care of both X and ourselves. At first we may feel a spark of surprise at their wisdom. Over time, we come to expect it.

"I'm worried about X," we may write, only to have the answer be: "There is no cause for worry. You are led carefully and well." Over and over, their advice places events squarely in the now. We are advised not to borrow trouble, rather to have faith. "You are in our custody," we are told. "You are safe and protected." Gradually, our sense of safety grows. The advice we hear from our heroes proves itself trustworthy. We are assured that "many here care for your well-being." Encouraged by such guidance, we learn to trust. Not only are our heroes looking out for us, others are as well. We begin to sense what might be called "higher forces"—benevolent beings concerned with our well-being. When we address higher forces, we may hear back Little One, a term of endearment. We are indeed little when compared to higher forces. We are like a babe in arms. At first we may resist such terms, but as time passes we relax and grow to appreciate them. We come to hear safety, and we come to cherish being cherished.

Our heroes take a kindly view of us. We may doubt our connection to them, but they do not doubt their connection to us. When we reach to them, they reach back to us. When we ask a question, they consider our question promptly and carefully.

Sometimes the questions are complicated and the answers are simple.

—DR. SEUSS

And so, again, I ask to hear from Bill Wilson. He promptly responds: "Julia, I can hear you and I bless you. There is a place for you and your work. Do not worry. I

find you stable and happy. There is great goodness afoot for you. You are led carefully and well. Do not fear the lessening of your powers; instead, celebrate your victories. You will be able to write well."

And next I write again to Carl Jung. I hear: "Ms. Cameron, how good to hear from you. You are at a gateway, and as you ask higher forces to guard and guide you, you will pass safely through. Depend on spiritual help. You are well connected."

◄ **TRY THIS** ►

Take pen in hand and address a personal hero. Ask to be guided and write out the guidance that you hear. Do not be surprised by the ease with which guidance comes to you. The listening path builds upon itself. You are led carefully and well.

WHISPERS IN THE WIND

I wake up early—too early. I burrow under my blankets, but it's no use. Sleep is a memory. Lying awake, I hear songbirds caroling in my garden, flitting from juniper to piñon. The snow is gone and the day is warm. Bright blue sky, white puffy clouds. Overnight, the iris in my garden have burst into bloom. They are white as snow, but announcing spring, not winter. Like the songbirds, they trumpet the change of seasons.

Now I hear a whirring sound. The wind is picking up. The forecast is for winds gusting up to fifty miles per hour. I am grateful not to be flying. Fifty miles per hour is the maximum planes can take off in. April and May are noted for their winds here in Santa Fe. I pad from my bedroom to my living room. A piñon tree whips across

the plate glass window. Perhaps because of my midwest-ern childhood featuring tornadoes, the sound of the wind makes me nervous. Lily is nervous as well. She looks ap-prehensively out the window, staring at the whiplashing piñon tree.

"It's okay, Lily," I tell her. "We don't have tornadoes here."

My soothing tone of voice calms her down. She crosses to my side, nuzzling my leg.

From the living room, I hear a shuddering sound. The wind is rattling the chimney.

"Maybe we do have tornadoes here," I catch myself thinking. Lily retreats to her favorite hiding spot: a corner behind my coatrack. Curled in a ball, she is determined to wait out the wind. Still in my pajamas, I, too, curl into a ball on my living room loveseat. The sound of the wind is primal. I am spooked. As always, when nervous, I take to the page. I am determined to write three page of longhand morning writing. "It's windy," my pages begin. "Very windy." The phone shrills and I race to answer it.

The caller is my friend Jay Stinnett, program director of the Mago Retreat Center in Sedona, Arizona. He greets me with a cheery note: "Hello, my beautiful friend." We launch directly into the deep end. Jay is writing a book about one of my heroes—AA co-founder Bill Wilson. Jay rises every morning at four thirty and takes to the page. He often wakes with the first line of what he is to write eddying in his head. He is obedient to this guidance. But the book is an uphill climb, he tells me, unfolding slowly, a page at a time. I tell him I, too, am writing a book, and that Bill Wilson figures also in my pages.

"It's called *The Listening Path*," I tell him.

"Ah. Ah, yes," he responds. A thirty-five-year vet-eran on a spiritual path, Stinnett is a longtime practi-tioner of listening. When I tell him my chapter on Bill Wilson is titled "Listening to Our Heroes," he chuckles

Everything you can imagine is real.

—PABLO PICASSO

appreciatively. Bill Wilson is a hero to him as well as to me. Stinnett has access to several hundred of Wilson's personal letters. In them, Wilson describes his deep interest in spiritualism.

"I had no experience with spiritualism," Stinnett tells me. "But now I take a real joy in it." He relates a weeklong visit he and his wife, Adele, took to Lily Dale, New York, a spiritualist center. "It's set in one of two old forests left in New York. There are eighty houses, and in order to live there, you must be a certified medium." Stinnett pauses, allowing the notion of eighty mediums to sink in. Then he continues. "Three times a day they hold sessions where mediums do cold readings for their audiences. We must have attended a hundred readings. They're very brief, but to the point. While we were there, our medium friend Lisa Williams did a reading with Bill Wilson and Dr. Bob Smith, AA's co-founders. Dr. Bob kept cracking jokes."

I tell Stinnett my own experience with reaching out to Dr. Bob. He said, "I'm much more lighthearted than my reputation allows."

"Yes, that's it!" Stinnett exclaims. Stinnett speaks of spirits fondly. His interactions with them have been positive. His contacts have been both easy and reliable. The "veil," in his experience, is easily transversed. Talking with him, I find my own experience validated.

I retreat to my bed. The wind is less loud in the bedroom. I resolve to make up for my missing sleep. I cuddle under my blankets, nearly asleep, when wham! Lily jumps on top of me, burrowing under the covers. I do not brush her off. Instead, I lie very still, drifting into sleep.

When I wake, hours later, Lily is still nestled sleeping. But the wind, the infernal wind, is blessedly gone.

It's the possibility of having a dream come true that makes life interesting.

—PAULO COELHO

CHECK IN

Have you kept up with your Morning Pages, Artist Dates, and Walks?

What have you discovered in consciously listening to your heroes?

Do you find a source of unexpected wisdom?

Did you experience resistance? Were you able to resist it?

Name one memorable experience of listening. What was the aha that came from it for you?

LISTENING
TO SILENCE

———⊃⊂⊃———

The word "listen" contains the same letters as the
word "silent."

—ALFRED BRENDEL

In the final week, we will consciously seek out silence. Now adept at listening in a myriad of ways, we will try for one more: listening to quiet. We will learn how to create silence around us and how to gain insight from it. We will learn what silence gives us—and how the absence of sound can create not isolation, but connection.

THE VALUE OF SILENCE

The sixth tool of the listening path may strike you as a non-tool. You have learned to listen acutely to sound, and now you practice listening acutely to the sound of silence. That's right: silence. It is by listening to the sound of no sound that we come to appreciate the sound of sound.

Silence takes getting used to. We are accustomed to sound. As we experience the sound of no sound, we come in contact with higher wisdom. Our thoughts race, then slow, then come to rest in quiet. It is then we begin to hear the "still small voice," which actually may loom quite large. As the minutes tick past, we experience a sense of direction. We are guided. We sense what our next step should be. In silence, we hear the voice of our creator. The listening path becomes deeper and richer. A great calm steals over our senses.

Silence at first feels threatening. We quake in its unexpected emptiness. As we become accustomed to the void, we find it isn't empty at all. Rather, it is filled with

Silence is the language of god; all else is poor translation.

—RUMI

a benevolent "something," a higher power that intends us good. As we lean into this presence, silence becomes friendly. Our terror at nothingness fades as we learn that "nothing" holds "something," after all.

The listening path requires attention, and nothing sharpens our attention like silence. As we strain to hear something—anything—our listening grows acute. The faintest sound captures our attention. We listen to sound, and we listen to quiet—the sound between sounds. We are cast into the present, hearing each moment. Our thoughts become spacious.

Each moment unfurls slowly. We set aside velocity in favor of attention. We experience languor and we find it pleasant. We feel the rhythm of our body a beat at a time. Peace—heretofore an unknown quality—seizes our senses. We experience calm, and the feeling is delicious.

Listening for silence, we experience the still small voice. We are meditating, although we may not call it that. Listening to silence, we hear the great, sonorous sound of the universe. Where there is nothing, a great something prevails.

When we listen for silence, it comes to us quickly. A moment or two and we are in the now. Our sense of time slips away. We sit for minutes that feel like hours. We sit for hours that feel like minutes.

A "Zen sit" of ten minutes goes by quickly—and slowly. The chime of a gong that calls an end to the time reverberates through us and through us. The soft chime is loud. We have grown accustomed to silence.

As we turn our attention back to the world, we find our thoughts sharpened. The time spent in silence has done its job. Our senses are alive and alert. We tread the listening path.

Silence, I discover, is something you can actually hear.

—HARUKI MURAKAMI

> ◄ **TRY THIS** ►
>
> Set a timer for three minutes. Close your eyes and allow the silence to nurture your spirit. Even the smallest amount of meditation is nourishing. For the next week, edge forward, adding three minutes more daily. By week's end, you will have arrived at twenty minutes, the amount of time allotted by most spiritual teachers.

SEEKING SILENCE

"But, Julia, I can't find a quiet spot anywhere!" I am often told. It is not always easy to find silence, but it is worth trying. I have had students say that they find the greatest silence—and great insight—swimming in a pool. Underwater, the world feels far away, and the altered sound environment brings them more in touch with themselves. Some live in the city, where there is hardly a moment without the sound of a siren, neighbor, or passing traffic. Others still live in chaotic households, with TVs, children, and pets, where there seems to be no chance for silence. For those whose lives are in no way quiet, I suggest exploring the possibilities.

Silence is Prayer.

—MOTHER TERESA

Sarah, a city dweller, finds that going to a church in the middle of the day brings far more quiet than she expected. "I'm not religious," she explains, "but I'll walk into a church and just sit there, listening for a few minutes. The quiet is striking. I can walk off of a city street into an unexpected oasis of serenity. At first I found it a little disconcerting—but after allowing myself to surrender to the quiet and listen to the silence, I found it to be a place of great peace and insight."

Others choose to go to libraries, where the hushed rows of books provide a quiet solace. Others still have

consciously driven to a quiet spot—an empty parking lot or a back road—and just taken a moment to listen to the quiet inside their car. Greta, a busy mom of three, says she sometimes just sits in her own driveway. "It sounds weird, maybe," she tells me, "but it works for me. I sometimes just stay in the car for a minute or two if I've run errands on my own or dropped the kids off at school—any time I have the car to myself, even for a brief time, I have the chance to seal myself in a quiet space. It helps me get my bearings, and it always calms me down." Simply sitting still and listening in the quietest place we can find can create a surprisingly drastic shift in our perceptions. Most commonly, I'm told that stopping and listening to silence brings a sense of calm and possibility. For me, I know that is true.

Most people are perfectly afraid of silence.

—E. E. CUMMINGS

"I feel intimidated by silence," my friend Jerry confesses. "I feel vulnerable when I really listen to the quiet, and I see myself trying to avoid it. My house always has the TV on, and the radio is always playing in my car. When I run, I listen to music or podcasts. I'm so attached to all of my devices—and their noise. I think I'm afraid to be alone with my thoughts."

This could be true, I tell Jerry, but I will encourage him to try it. "What about five minutes of silence?" I counter. "Or two? As an experiment?"

"Can I try it and call you back?" he says, his anxiety palpable through the phone.

"I'll be here."

A few minutes later, my phone shrills. It is Jerry, reporting in. "I turned off all the noise in the house, and I sat down and listened," he says. "It felt foreign and made me nervous. But it was also interesting to me. I remembered something I needed to do today, and I had a few ideas about how I should structure my workweek."

"Sounds like insight," I reply.

"I think I'll try it again," he says. I smile as I hang up the phone.

Time and time again, I have seen my students and friends feel nervous about seeking silence. It is, indeed, a foreign experience for most people. Even those who live quiet lives in quiet places tend to surround themselves with familiar sounds, whether it is the TV or the radio or the pinging of the cell phone. And time and time again, I have seen the value of creating silence however we can and listening to that silence. Stepping out of our comfort zone, we step into possibility. In silence, there are answers.

For all evils there are two remedies—time and silence.

—ALEXANDRE DUMAS

◄ **TRY THIS** ►

Create—or find—the quietest environment you can. Perhaps it is a church or a library. Perhaps it is at home, with devices turned off. Whatever you choose, allow yourself to seek it out—and then enter it. Note your resistance, if you feel it. Do you feel nervous that you will miss something by turning off your phone? Do you feel uneasy without the chatter of people or television in the background? Allow yourself to resist your own resistance. Spend a few minutes in silence, and consciously listen. Does the anxiety subside? Do you "hear" insights or ideas? Do you sense a connection to a higher force? When you reenter your familiar sonic world, are the sounds more pronounced? Do you have a new perspective on them? Did a sense of calm stay with you after moving from quiet to sound?

Try making this a regular habit. Like any habit, it can become more natural with practice.

LISTENING FOR THE VOICE OF GOD

I sit down for lunch at the Santa Fe Bar & Grill with my friend Scottie. She sports modern glasses in festive red ombré. I ask her about them, and decide I, too, will visit the downtown optical shop she recommends. "There are lots of European designs there," she tells me. "And glasses are just fun. I have pairs in almost every color—I enjoy accessorizing with them."

I tell her that I am almost finished with my book. She is thrilled; she is always an enthusiastic believing mirror for me, with an easy faith in my process that inspires me to keep moving forward.

"How does it end?" she wants to know.

"Well, I write about listening to silence."

She laughs delightedly. "Yes, yes." She nods. "You know I sit quiet every morning, and often every evening," she shares.

I nod that I do.

"I light incense and I even sit quiet with my dogs. They've learned to do that," she says serenely.

I smile, thinking that I'm not sure I can train Lily to do the same.

"It's in silence," Scottie continues, "that I hear the voice of God."

I meet her eyes, interested. "Yes," I agree. "I understand."

"I've learned that with time sitting quiet, I can always find the guidance I seek," she continues. I believe that she is not alone. I myself have found this to be true, and I know of many others who employ a similar practice, and are led to higher insight from a power greater than themselves—which they may or may not choose to call God.

"It doesn't matter what you call it," I often tell my students. "It just matters that you keep an open mind to

Silence is sometimes the best answer.

—DALAI LAMA XIV

the idea that there may be more help available than you might assume." We are led, and we are encouraged by a higher force if we are willing to seek its guidance.

I think of traditions that hold silence, and either directly or indirectly invoke the presence of something greater: "a moment of silence" for someone who is suffering or lost; the tradition of silent meditation as a route to contact with God in convents or monasteries; the instinctive practice of holding silence with others when mourning a death. The idea of silent prayer, as we directly ask for help; the impulse to be silent and just "hold the space" when someone near us is in pain. In all of these instances, we are naturally open to—and even looking for—support from something beyond ourselves.

Yes, silence is powerful. Yes, in silence, we can seek—and hear—the voice of a benevolent something.

Silence is a source of Great Strength.

—LAO TZU

◄ **TRY THIS** ►

I ask you now to experiment with open-mindedness. You do not need to use the word "God" to describe whatever higher force you are willing to connect with. I was raised Catholic and have often described that upbringing as "the greased slide to atheism." When I got sober, my elders told me I had to believe in a higher power—and I bucked, explaining that it just wasn't going to be in the cards for me.

"It doesn't have to be called God," they advised me. So I decided I could believe in a line from a Dylan Thomas poem: "the force that through the green fuse drives the flower." I still believe in this force. I believe it represents the force of creation—creativity and spirituality—which I believe are one and the same.

So I ask you to find any version of a higher force and sit in silence, with the intention to be open to

(cont'd)

it. You may sit quiet and listen, you may mentally ask a question or express a worry—whatever is most pressing in your mind is the place to begin. Do you "hear" guidance? Do you sense peace? Do you simply feel some amount of relief or relaxation? Allow yourself to experiment with opening yourself to silence, and note what you find there.

THE NEIGHBORS REJOICE

Puffy white clouds are snagged on the mountain peaks. A light breeze stirs the piñon tree. Lily is outside on patrol, sporting a new "anti-bark" collar. When and if she barks, it triggers a citronella spray, a smell dogs hate. She will soon learn that to bark causes unpleasantness. I phone my neighbors and tell them the measures I have taken. This evening, quiet should reign.

Nick Kapustinsky came to my rescue, deciphering the complex instructions for the collar and fitting it snugly to Lily's neck. While he worked on adjusting it, Lily hovered near his knees. He talked to her as he labored. Lily was ecstatic with the attention.

I've begun to realize that you can listen to silence and learn from it. It has a quality and a dimension all its own.

—CHAIM POTOK

"Here you go, girl. Don't you look pretty with your new collar. You're such a fancy lady. Let me just get it right. A little more snug. There—that seems just about perfect. You're such a good girl."

Nick's praise lingers in the air when he leaves. When Lily comes back inside, I imitate him—talking to Lily more, not less.

"Good girl," I tell her. "Good girl. Aren't you a lovely little dog." Lily lies down, stretching out her full length, wriggling her neck, adjusting to the new collar. But she doesn't bark. She doesn't even woof.

I call Emma and tell her of Nick's kindly intervention.

"So it sprays her, not shocks her?" Emma asks.

"Yes."

"That's much better." Emma, like Nick, is a dog lover.

"I agree. She may not like the spray, but it doesn't hurt her. Tonight she should be quiet. Here's hoping."

Hanging up with Emma, I turn my attention one more time to Lily, asking her, "Did you hear that, girl? No barking tonight." Lily doesn't meet my eyes. She may suspect that I am the villain behind her new collar.

It's twilight, a full day later. I—and the neighbors—passed a bark-free night. I call Nick to tell him of our triumph. He says, "Lily's a smart dog. She may already have figured out barking equals spray." All day long, Lily doesn't bark. She doesn't even woof. Nick may be right that she has already figured out cause and effect: bark causes spray.

"You're such a little smarty," I tell her. Whether from my tone or her vocabulary, she soaks in the praise. Her tail thumps the floor. Then she crosses to my side for a tussle. "You're such a good girl," I tell her. "Such a smarty."

I note the irony of my situation: while writing a book on listening, my dog has disturbed the neighbors with her noise. At least we have found a solution.

◄ TRY THIS ►

You have completed six weeks of listening. What changes have you noted—or created—in your environment? Do you feel more connected to the world, the people, and the higher forces around you? Have you noticed a shift in those you listen to? As you listen more closely, do they?

CHECK IN

Have you kept up with your Morning Pages, Artist Dates, and Walks?

What have you discovered in consciously listening to silence?

Do you find that you feel more connected to yourself?

Did you experience resistance? Were you able to resist it?

Name one memorable experience of listening. What was the aha that came from it for you?

AFTERWORD

Spring has sprung. Fruit trees put forth a festive froth. Forsythia and lilac bushes scent the air. High in a newly green willow tree, songbirds send out cascading notes. Little Lily is alert to sight and sound. Winter's quiet has passed. We have spring, summer, and fall—three seasons of song to look forward to. The listening path is in full bloom.

It is easy, walking out, to become intoxicated by your senses. The gay trilling of birds lifts the heart. "Where have you been so long?" we mentally ask. "Never mind, we're back now," the birds respond.

In the winter, we had silence, or the hoarse cawing of ravens. Spring birds lilt their tunes, many birds singing at once. From the treetops, sonatas sound. A full-throated choir greets the day. Across Lily's path, a silent beetle trudges. Enchanted by sound, she pays it no heed. Approaching her friend Otis's play yard, Lily woofs a greeting, soft and musical on the spring air. Otis's woof comes back to her: basso profundo. He is a big dog.

Back at home, Lily eddies by the door. She knows that crunchy dog food awaits her. The walk has whetted her

In Silence there is eloquence.
Stop weaving and see how
the pattern improves.

—RUMI

appetite. As I settle in to write, she chomps with fierce concentration. Her dog tags twinkle like tiny bells against the edge of the bowl. Suddenly she stops eating. I hear her skittering across the tile floor. She is in pursuit of a yellow butterfly that somehow slipped indoors.

It is my hope that you have journeyed along the listening path alongside me, and that the journey has been a rewarding one for you. It is my hope that each type of listening has become habitual to you; that you move among them with ease, noting the world around you, connecting to those you know, and reaching to your higher self, your beloveds, your heroes, and even to silence, as you need to. The tools of the listening path are portable and free, to be taken anywhere and used in any situation. It is my experience that listening deeply is always worthwhile and always rewarding.

I move out into the courtyard, taking in the fresh spring breeze. The tall birch trees glitter in the afternoon light as their many leaves rattle, sounding like a gentle rainstick at the end of their swaying branches. Listening, I connect to the world around me. Connecting to the world around me, I listen.

ACKNOWLEDGMENTS

Jeannette Aycock, for her guidance

Scott Bercu, for his care

Gerard Hackett, for his loyalty

Emma Lively, for her artistry

Susan Raihofer, for her diligence

Domenica Cameron-Scorsese, for her faith

Ed Towle, for his belief

INDEX

AA. *See* Alcoholics Anonymous
Aborigines, 34
acceptance, of emotions,
 114–15
act of love, 99–101
acting, 14, 88
actor, as listener, 92–94
ADD. *See* attention deficit
 disorder
adventure, deliberate, 57
advice, 107–9
 from believing mirrors, 66
 from heroes, 161
 spiritual, 152
 unsolicited, 104–6, 108
afterlife, 148, 150, 160
alarm clocks, 39
Albom, Mitch, 146, 151
Alcoholics Anonymous (AA),
 158, 160, 163, 164
alcoholism, 158
ancestors, 145
Anderson, Walter, 81
anxiety, 125
 inner guidance for, 130
 quelling, 127–29
 silence causing, 172–73

archetypes, 159
arrogance, 105
art, 14, 22, 72, 134
Artist Dates, 4, 20, 22, 26,
 28–29
 attention and, 25
 enjoyment on, 24
 as inspiration, 27
 intuition on, 23
 perspective altered by, 30
 playlists for, 21
 spirituality and, 23
Artist's Way intensive,
 127
aspen trees, 54, 55, 56
attention, 2, 14, 16, 22, 25,
 62–63
 silence sharpening, 170
attention deficit disorder
 (ADD), 83
audiobooks, 78–79
Augsburger, David W., 65
Austen, Jane, 79, 129
authenticity, 82–84

barking dog, 43–46, 176–77
Baruch, Bernard M., 74

Bassey, Jennifer, 65, 69–70, 82–83, 86–87, 102–3
Batchelor, Brendalyn, 135–37
beauty, inner, 138
believing mirrors, 18–19, 33, 66, 67, 68, 115
beloved, photo of, 76
blinking eyes, 94
body language, 63, 64, 93, 94, 140
body work, as spiritual path, 138
Bowers, John, 78–79
bravery, 125
breakthroughs, creative, 23
Brendel, Alfred, 167
Brothers, Joyce, 76
Brown, Brene, 97, 149
Brunton, Paul, 127
Buddhism, 34, 42
Burrell, Anne, 71
Butterworth, Hazel, 120
buying, house, 66, 115

Cameron, Julia, 18–19, 35, 125
Campbell, Don, 41
Catholicism, 175
Cecil, Jane, 146
changes, 12, 43
 in environment, 177
 of seasons, 162, 179
 in students, 4
check ins, 58, 109–10, 115–16, 141, 152–53, 165, 178
Chesterton, G. K., 50
Choquette, Sonia, 19, 149
Christensen, Todd, 80
Christie, Agatha, 83
church, 171
city sounds, 132
clarity, 3
Clayton, Meg Waite, 88
codependency withdrawal, 13
Coelho, Paulo, 164

communiqués, 146
connection, 2, 26, 88
 art and, 134
 to heroes, 157
 with spirits, 149, 151–52
 to world beyond, 145–50, 152
consciousness, 6
control, surrendering, 87–89
conversationalist, listener as, 95–96
conversations, 72, 95, 96
 with deceased loved ones, 146–50
 with dog, 56
 emotions in, 62
 with friends, 74
 interrupting, 3, 67, 80, 82, 84
 music of, 61–68
Coolidge, Calvin, 59
Covey, Stephen R., 95
creative energy, 14–15
creativity, 4, 13, 23, 33, 118, 175
creator. See great creator
critic, inner, 117
Cummings, E. E., 56, 172
Cunningham, Ed, 64

da Vinci, Leonardo, 147
dailiness, 101–3
daily soundtrack, 39–42, 43
Dalai Lama XIV, 174
Das, Avijeet, 41
deceased loved ones, 145–50
deliberate adventure, 57
denial, 6, 65
depression, 29
Dhiliwayo, Matshona, 137
Dillon, Doug, 39
Disney, Walt, 157
dogs. See also Lily
 barking, 43–46, 176–77
 conversation with, 56

Dr. Seuss, 161
dreams, 13–14 16
driving, 55
drum music, 42
Dumas, Alexandre, 173
Dybas, James, 92

ego, 9
Einstein, Albert, 158
Emerson, Ralph Waldo, 44,
 77, 126, 160
emotions
 acceptance of, 114–15
 in conversation, 62
 and music, 41
empathy, 63, 64, 100
endorphins, 31, 32
energy, creative, 14–15
enjoyment, on Artist Dates,
 24
environment, 61
 changes in, 177
 quiet, 173
 sonic, 39, 43, 46–54
 sounds of, 31, 54, 171
evening check-ins, 115
"evening pages," compared to
 Morning Pages, 12
exercise, 33, 137–38
eyes, blinking, 94

faith, trust and, 17, 116–17
falling in love, 83, 84, 89
family mythology, 18
Faulkner, William, 49
fear, 16, 172–73
fitness, 33, 137–38, 139
Flaubert, Gustave, 111, 123
flute music, 42
focus, 99
Forbes, Malcolm, 91
forces, higher, 126, 161, 162,
 175–76
friends, 74, 106–7, 140, 145
fun, importance of, 29, 30

Gawain, Shakti, 116, 140
gentle sounds, 41
Gill, Peg, 76–78
The Gin Game (play), 93
Giten, Dhyan, 121
God, 7, 11, 23, 26, 94,
 136–37
 connection to, 34
 listening by, 119
 music and, 41
 prayer and, 114
 voice of, 174–75
Goldberg, Natalie, 33, 40
Goodrich, Richelle E., 69
gratitude, 11, 26, 129
Great Creator, 117–18, 161
guidance, 3, 119, 141
 from heroes, 158, 160–61
 for "hot spots," 124
 imagination and, 121
 inner, 113–15, 116, 128,
 130, 160
 spiritual, 152
guide, spirit, 152

habits, 12, 39
Hackett, Gerard, 66–67,
 95–96, 129
Hammerstein II, Oscar, 157
Hanh, Thich Nhat, 62
Hay, Louise, L., 119
Hazlitt, William, 102
head and heart, 119–21, 151
healing, 2
healing sound, 41
health, 138–39
hearing, 50, 127
 deceased loved ones, 145–47
 listening contrasted with,
 93, 100
heart
 head and, 119–21, 151
 listening to, 90
 writing from, 124
Henson, Jim, 125

heroes, 3, 155, 165
 advice from, 161
 guidance from, 158, 160–61
 speaking, 157–62
 value system matching,
 157–58
 writing to, 160, 162
higher forces, 126, 161, 162,
 175–76
higher self, 3, 35, 111–41
Holmes, Ernest, 114
honesty, 4, 5
Honstein, Elberta, 146–48
horses, 26, 146, 152
"hot spots," guidance for, 124
house buying, 66, 115
Howard, Vernon, 130
Hubbard, Ezra, 71–73
human face, listening to, 75–76

imagination, 28–29, 121
inaudible voice, 86–87
inner beauty, 138
inner critic, 117
"inner elder," 115
inner guidance, 113–15, 116,
 128, 130, 160
inner listening, 62
inner wisdom, 7, 115, 119,
 135, 141
"inner youngster," 22
Inside Columbia (magazine),
 76–77
inspiration, 22, 27, 126
instincts, 81
intellect, 120–21
intentions, 61, 62, 157
interrupting, conversation, 3,
 67, 80, 82, 84
intuition, 7, 16, 23, 62, 120
Isaacson, Walter, 157
Isham, J., 100

Jobs, Steve, 117
journalism, 68–69

journalist, as listener, 76–78
Judeo-Christianity, 26
Jung, Carl, 158–59, 162

Kapustinsky, Nick, 52, 53,
 64–65, 73–74, 176–77
Keats, John, 46
Koontz, Dean, 138

Lander, Susan, 150–52
language. See body language
learning, by listening, 73–74,
 79–80
Lee, Harper, 68
L'Engle, Madeleine, 37, 134
"letting go," 23
libraries, 171–72
Lily Dale, New York, 164
Lily (dog), 54, 90, 97, 101–2,
 118, 179–80
 barking, 43–46, 176–77
 sounds on walk of, 57–58
 storms and, 46–52
listeners
 actor as, 92–94
 conversationalist as, 95–96
 journalist as, 76–78
 location scout as, 80–81
 minister as, 135–37
 musician as, 84–85
 novelist as, 78–79
 painter as, 133–35
 realtor as, 139–41
 sculptor as, 70–73
 teacher as, 97–99
 women as great, 82–83
Little One, term of
 endearment, 161
Lively, Emma, 19, 44, 66, 69,
 84–85
Livon, Jodi, 136
location scout, as listener,
 80–81
log, of daily soundtrack, 43
loneliness, 77–78

love, 83, 84, 89, 99–101,
 134
love letter, writing, 133
loved ones, deceased
 conversations with, 146–50
 hearing, 145–47
 writing to, 148, 150
lyrics, writing, 85

making art, 22
making friends, 140
Mandela, Nelson, 14
mantra, for Morning Pages, 19
Markoya, Pamela, 133–35
McCarthy, Julianna, 33
McKenna, Terance, 46
meditation, 6–7, 34, 94, 136,
 170–71
mediums, 150, 151, 164
memory, 83
"mental cigarette breaks," 13
Miller, Alice Duer, 63
mindfulness, 42
minister, as listener, 135–37
mirrors. *See* believing mirrors
mischief, 24
Morning Pages, 5, 9, 13–18,
 20, 72, 88
 "evening pages" compared
 to, 12
 gratitude and, 11
 mantra for, 19
 as meditation, 6–7
 spirituality and, 7, 8, 11–12
 synchronicity and, 10–11
Mother Teresa, 171
movies, 82
Mozart's Ghost (Cameron),
 18–19
Mulvaney, Cynthia, 75
Murakami, Haruki, 170
Murphy, Kate, 79
music, 41, 42, 85–86
 of conversation, 61–68
 writing, 17–18

musician, as listener, 84–85
mythology, family, 18

Native Americans, 34
nature, 31, 32. *See also* seasons,
 change of; weather
Navé, James, 99–100
Nazarian, Vera, 56
neighbors, rejoicing, 176
New Mexico, 55
 Santa Fe, 1, 32, 130–32,
 162, 179
 storms in, 46–54
Nhat Hanh, Thich, 42
Nichols, John, 34
Nichols, Ralph G., 62
Nietzsche, Friedrich, 146
Nigel (inner critic), 117
Nin, Anaïs, 159
Nordby, Jacob, 122–23
Nouwen, Henri J. M., 85
novelist, as listener, 78–79

Obi-Wan Kenobi tool, 113,
 115
Oliver, Mary, 52
optimism, 11, 32
others
 respect for, 89
 speaking, 90–92
outer listening, 62

pace, slow, 139
pages. *See* Morning Pages
painter, as listener, 133–35
passions, identifying, 99
pathology, speech, 151
patience, 67–68, 78, 80, 99
paying attention, 2, 22. *See also*
 attention
Peck, M. Scott, 105
perfectionism, 15–16
perspective, Artist Dates
 altering, 30
photo, of beloved, 76

Picasso, Pablo, 163
Pierce, Scottie, 64, 66, 122,
 125, 131–32
 on conversations with
 deceased, 148–49
 on voice of God, 174–75
play, 20, 21, 23, 24
"play ethic," 20
playfulness, 20–21, 23, 24,
 28–29
playlists, for Artist Dates, 21
Post, Emily, 74
postcard, for conversation, 96
Potok, Chaim, 176
prayer, 94, 113, 114, 125, 136,
 147
Prayers to the Great Creator
 (Cameron), 125
procrastination, 13
psychics, 149, 150

Qualls, Thomas Lloyd, 43
quelling anxiety, 127–29
questions, for inner guidance,
 116
quiet, of snow, 121–24
quiet environment, 173

radio kit, spiritual, 137
Ramaru, Unarine, 155
reading, 79, 125–27
real estate, 139–40
realtor, as listener, 139–41
reciprocity, and conversation,
 67
Region, Daniel, 87–89
rejoicing, neighbors, 176
release, practicing, 23
resistance, 141, 145, 173
 facing, 20
 as misunderstanding, 104
 to play, 20
respect, for others, 89
Rolling Stone, 68
Rowling, J. K., 152

Rumi, 45, 115, 126, 127, 169,
 179

Santa Fe, New Mexico, 1, 32,
 130–32, 162, 179
sculptor, as listener, 70–73
Sealy, Suzanne, 139–41
séances, 160
Searls, David, 143
seasons, change of, 162, 179
seeking silence, 171–73
self, higher, 3, 35, 111–41
self-acceptance, 9
self-knowledge, 9
senses, awakening, 27
silence, 3, 167, 178
 anxiety caused by, 172–73
 attention sharpened by, 170
 fear of, 172–73
 meditation in, 170–71
 seeking, 171–73
 sounds of, 169
 traditions of, 175
 value of, 169–70
slow pace, 139
small voice, 113–21, 136, 141
Smith, Bob, 164
snow, quiet of, 121–24
sobriety, 146, 158
solo time, 22
sonic environment, 39, 43,
 46–54
sound healing, 41
sounds, 31. *See also* sonic
 environment
 city, 132
 of environment, 31, 54, 171
 of Lily's walk, 57–58
 of silence, 169
 staccato, 41
 tuning in to, 39, 40, 43
 tuning out, 3, 31, 39, 40,
 43, 46, 104
 of wind, 163
soundscape, 132

soundtrack. *See* daily
 soundtrack
speaking, 90–92, 157–62
speech pathology, 151
Speechley, Graham, 58
spirit guide, 152
spirits, 149, 151–52, 164
spiritual listening, 136
spiritual path, 12, 135–36,
 138
spiritual radio kit, 137
spirituality, 160, 162
 advice and, 152
 art and, 72
 creativity and, 175
 Morning Pages and, 7, 8,
 11–12
 music and, 41–42
 the veil and, 145
 Walks and, 34
 Wilson and, 164
spring, in Santa Fe, 130–32,
 162, 179
staccato sounds, 41
Stinnett, Jay, 163–64
Stivers, Robert, 25
storms, in New Mexico,
 46–52, 53–54
stream of consciousness, 5
students, changes in, 4
surrendering control, 87–89
synchronicity, Morning Pages
 and, 10–11

Tagore, Rabindranath, 54
talents, 17
talking, 151. *See also*
 conversations
teacher, 97–99, 134
term of endearment, Little
 One, 161
Thien, Madeleine, 42
thinking, wishful, 148
Thomas, Dylan, 14, 175
Thoreau, Henry David, 66

tone of voice, 61–62, 94, 98
tornadoes, 163
traditions, of silence, 175
traveling, 125–26, 127–29
trees, 117–18
Trotman, Wayne Gerard, 113
trust, 17, 116–17, 149
truth, 5, 9
tuning in, to sounds, 39, 40,
 43
tuning out, sounds, 3, 31, 39,
 40, 46, 104
 sonic environment, 43
Turkish proverb, 94
Tzu, Lao, 175

Ueland, Brenda, 33–34
"the undefended self," 9
universe, 114, 134
unsolicited advice, 104–6, 108

value, of silence, 169–70
value system, heroes matching,
 157–58
the veil, 3, 143, 145, 150–53
vision quests, 34
voice
 of God, 174–75
 inaudible, 86–87
 small, 113–21, 136, 141
 tone of, 61–62, 94, 98
von Goethe, Johann Wolfgang,
 149

walkabouts, 34
walking, 30–36
walking exercise, 137–38
Walking in This World
 (Cameron), 35
walking meditation, 34
Walks, 4, 30–31, 33, 35–36,
 73
 optimism brought by, 32
 spirituality and, 34
Warsa, Michele, 137–39

Washington Post, 68
weather
 seasons, change of, 162, 179
 snowy, 121–24
 stormy, 46–49, 50–54
 windy, 162–65
 writing report for, 54
whispers, in wind, 162–65
Wiccans, 34
Wilson, Bill, 158–60, 161–62,
 163–64
wind, whispers in, 162–65
wisdom, inner, 7, 115, 119,
 135, 141
"wishful thinking," 148
withdrawal, codependency, 13
women, as great listeners,
 82–83

work ethic, 20, 23
world beyond, connecting to,
 145–50
Wright, H. Norman, 72
writing, 5, 123. *See also*
 Morning Pages
 to deceased loved ones, 148,
 150
 from the heart, 124
 to heroes, 160, 162
 love letters, 133
 lyrics, 85
 music, 17–18
 weather report, 54
Writing Down the Bones
 (Goldberg), 33

"Zen sit," 170